Organization/Composition & Cover Design: YASUHIRO NITTA
Production Supervisor: KEN SASAHARA
Translation: THE EAST PUBLICATIONS, INC.
Publisher: HIKARU SASAHARA
Japan Relations: JOHN WHALEN
Print Production Manager FRED LUI

LET'S DRAW MANGA
Transforming Robots

English Edition Published by
DIGITAL MANGA PUBLISHING
1123 Dominguez Street, Unit K
Carson, CA 90746
www.emanga.com
tel: (310) 604-9701
fax: (310) 604-1134

Distributed Exclusively in North America by
WATSON-GUPTILL PUBLICATIONS
a division of VNU Business Media
770 Broadway, New York, NY 10003
www.watsonguptill.com

ISBN: 1-56970-991-2
Library of Congress Control Number: 2003095712
First Edition September 2003
10 9 8 7 6 5 4 3 2 1

Printed in Canada

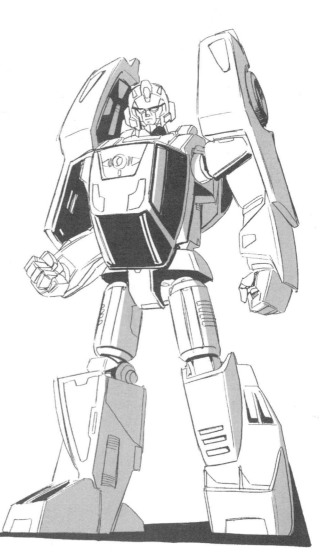

TRANSFORMING ROBOTS

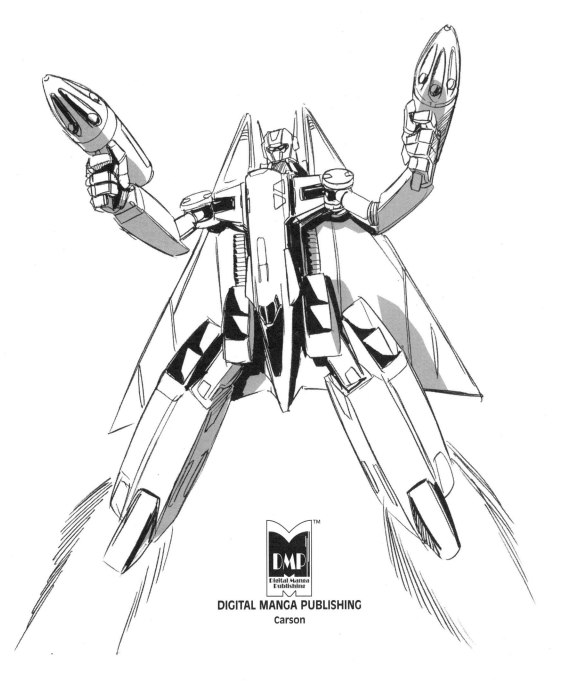

DIGITAL MANGA PUBLISHING

Carson

CONTENTS

PLEX that designs dreams–

PLEX International Design was originally established in 1981 under the name "Popy Planning Room," specializing in the planning, development and design of character toys in Japan.

Soon thereafter, PLEX entered into a business arrangement centered around design and development with the Bandai Group. Their work now ranges from the planning and development of Bandai products to the C.I. production for all of Bandai.

Since 2001, PLEX's main business includes the planning, designing, development, and productionof all types of merchandise, with the focus centered on TV characters. PLEX's head office is located in Tokyo and has an additional branch office in Hong Kong. Now, PLEX is planning to establish a new business in the United States. This "Let's Draw Manga" title is one of the new projects of PLEX.

PLEX creates the concept and design for the heroes, mechanics, and toys of Japan's "SENTAI-SERIES" and the "Power Rangers" series in the United States. PLEX also provides designs for the heroes, mechanics, and toys of Masked Rider Kuuga, Agito, Ryuki, and Ultraman (Tiga, Dina, Gaia, and Cosmos) series' toys and mechanics.

Most Recent Works of PLEX:
Super Sentai Series – Japan
Mighty Morphin' Power Rangers Series – USA
Masked Rider Series: KUUGA, AGITO, RYUKI and FAIZ – Japan
Ultraman Series: TIGA, Dina, Gaia and Cosmos – Japan
Digimon
GUNDAM
Robo Wheels – Mattel

Address:
PLEX Co., Ltd.
Kyobashi TD Bldg., 4F, 1-2-5 Kyobashi
Chuo-ku, Tokyo 104-0031 JAPAN

Tel: 011-03-5205-1525
Fax: 011-03-5205-1520

Please feel free to contact us directly or visit us on the web at:
http://www.plex-web.com

Chapter 1

Designing Transforming Robots

History of Transforming Robots Design (Part 1)

PLEX Transforming Robot designs began in 1982 and took off with the commercialization of the *Machine Robo* series. The miniature zinc-alloy car series with its solid look, small size, and elaborate transformations has remained popular over the years. Overseas these cars have been branded and sold as *Go-Bots* and appeared as an animated series on television in 1983.

An array of merchandise from the *Machine Robo* series. Swift transformation from machine to robot.

The *Machine Robo* series began as small robots with a total length of 8cm. Later, robots over 20cm were included in the latter part of the animated series. Rather than increase robot sizes, designs emphasizing elaborate gimmicks and dynamic transformations grew. Robots that were capable of transforming into any shape appeared.

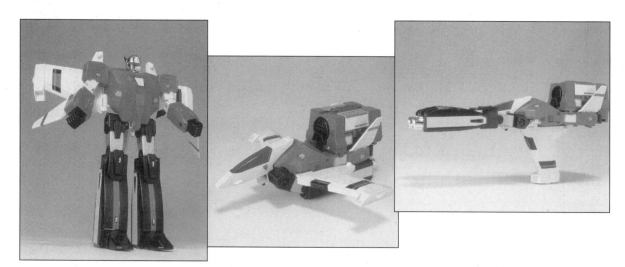

The *Mach Blaster* is capable of transforming into three shapes—a robot, jet and handgun.

History of Transforming Robots Design (Part 2)

The *Double Morphing Rescue Megazord*, a step up from the *Power Rangers Turbo*, comprises five Rescue Zord vehicles which each transform into a robot. Each figure also morphs to form a giant robot.

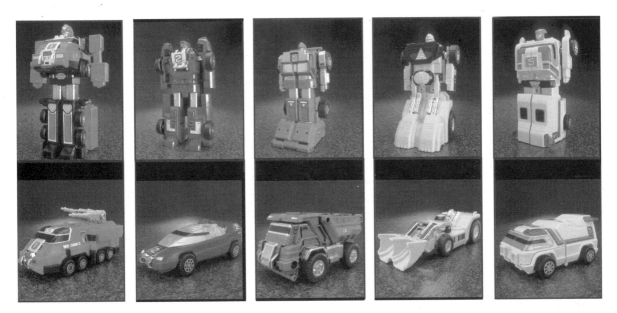

In 1993, the *Power Rangers* came to screens around the world after a 25-year stint in Japan as the *Super Sentai* series. It was PLEX who designed the robots appearing in the *Power Rangers*. Robots merchandised from the program could naturally transform from machine to robot and could also be assembled into one enormous piece. When it comes to this sort of design work, PLEX has accumulated matchless techniques and know-how, coupled with the marketing ability needed to make a product succeed.

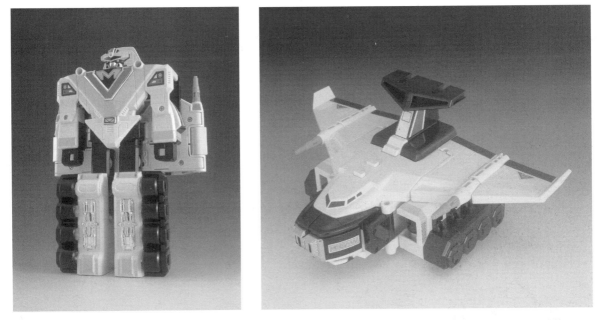

From Power Rangers in Space comes the *MegaWinger*. PLEX has the expertise to enable any machine to morph into a humanoid.

History of Transforming Robots Design (Part 3)

In 2001, PLEX designed a new transforming robot, later marketed by America's Mattel as *Robo Wheels*. This transforming robot was marketed under Mattel's famous miniature car series, *Hot Wheels*. Having a car that transforms into a robot was old news. *Robo Wheels*, however, was streets apart. The chassis of the car remained in place like a skateboard and the car body made up the torso of the robot. This enabled transformation to a humanoid while in motion and allowed the transforming robots to move as if riding atop a skateboard.

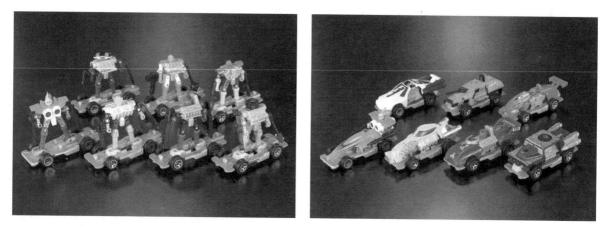

Robo Wheels can cruise at high speed as either a machine or robot.

After a long hiatus, *Machine Robo* revived in Japan as a television series in 2002 under the name *Machine Robo Rescue*. The five machines similar in size to the Machine Robos of the 1980s are capable of forming a single team and transforming into individual robots. Put together, these five machines form a giant robot. Additionally, the massive machine that houses these five machines is capable of transformation into an enormous robot. The *Machine Robo Rescue* series could be called PLEX's transforming robot compilation.

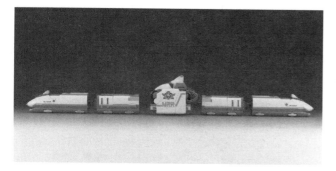

From *Machine Robo Rescue* comes *Wing Liner,* capable of storing five Machine Robos in train mode (high-speed transport).

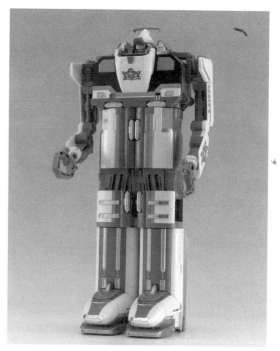

Wing Liner in robot mode. Transformation into a massive robot allows for the support of *Machine Robo*.

History of Transforming Robots Design (Part 4)

The many transforming robots that appear in the *Machine Robo Rescue* also showcase unique designs. *Gear Dump*, for example, is a transforming robot designed in the form of a large dump truck. To emphasize the robot's strength, the legs have been done away with and the large wheels of the dump truck have been put to use in their original form.

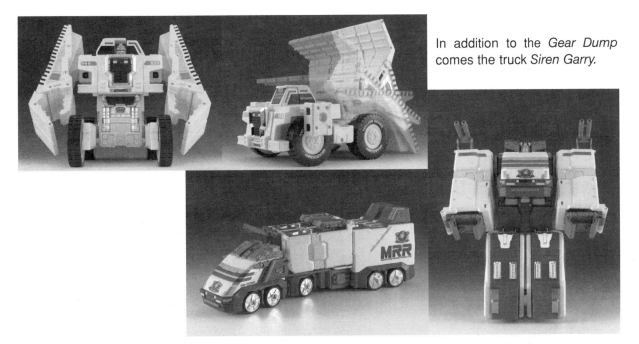

In addition to the *Gear Dump* comes the truck *Siren Garry.*

The *Machine Robo Rescue* line up. PLEX has been engaged in designing numerous transforming robots, all of which are guaranteed success when they hit the market.

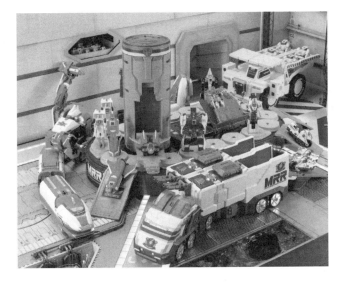

This book is based on PLEX's accumulated experience in the area of transforming robots and has been created to provide a simple explanation for beginners who'd like to develop a feel for designing and drawing transforming robots. So pick up a pen and let's get cracking!

PLEX Design Works

Introduction of PLEX

Come and visit PLEX!

In April 1981, PLEX set up an office in Tokyo as a toy character design company under the name "Popy Planning Room". Over the last 20 years the company has been engaged in the development of action-hero toys. In 1990, the company name changed to PLEX Co., Ltd. and the PLEX Hong Kong branch was established, resulting in an expansion of operations and increased diversification.

Foreign audiences may be familiar with the *Power Ranger* series, *Go-Bots*, *Ultraman* and *Masked Rider*, all toys developed and designed by PLEX. These same characters appeared in the Japanese market under the names *Super Sentai* series, 1981, *Metal Hero* series, 1982, *Machine Robo* series, 1982, *Heisei Ultraman* series, 1996, and the *Heisei Kamen Rider* series, 2000. Add to this the *Gundam MS in Action* series and it is clear that PLEX stands at the top of the world in planning and creating hit characters.

Our head office in Japan is mainly involved in planning and design while the Hong Kong branch is engaged in development strategy. In recent years operations have expanded to include entertainment content for mobile phones, comic book publications, and a *Sailor Moon* live show. The transforming robots introduced in this book showcase the robot design techniques in which PLEX excels. It is our hope that this book creates an interest in our company and that talented personnel can be fostered to one day work with our manager, Mr. Nitta, project coordinator and staff.

Following this book we hope to unveil other books on how to draw Monsters, *Gundam*, *Sailor Moon* and other characters. Expect PLEX's gifted staff to be involved in writing these books too.

Masayuki Kondo
PLEX Managing Director

Chapter 2

Transforming

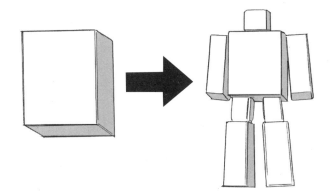

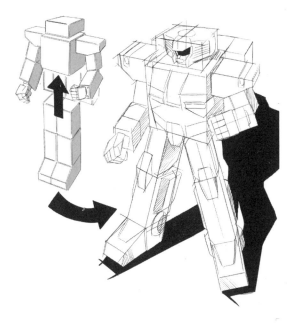

Transformation from a Cuboid

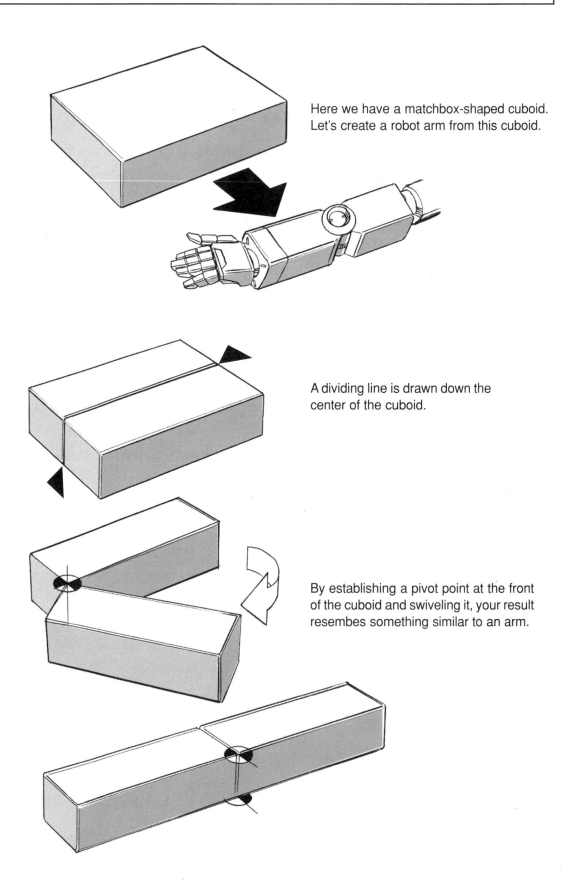

Here we have a matchbox-shaped cuboid. Let's create a robot arm from this cuboid.

A dividing line is drawn down the center of the cuboid.

By establishing a pivot point at the front of the cuboid and swiveling it, your result resembes something similar to an arm.

Transformation from a Cuboid

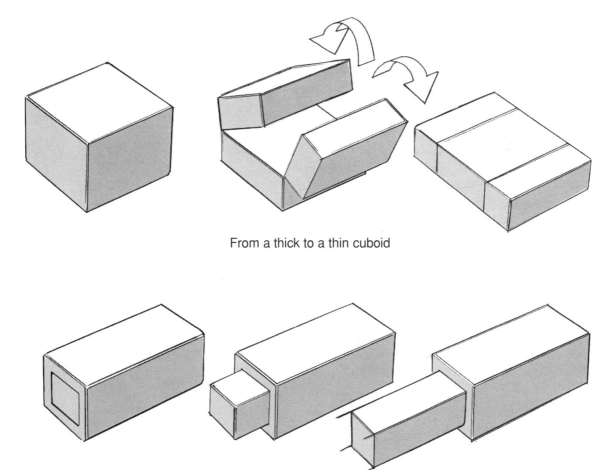

From a thick to a thin cuboid

Create a rectangular shape and elongate it

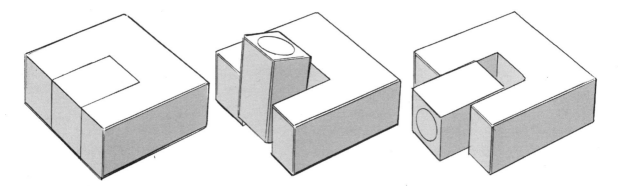

Cut out a part and expose the area that was unseen. This is one of many methods for creating a transformer.

From Cuboid to Humanoid

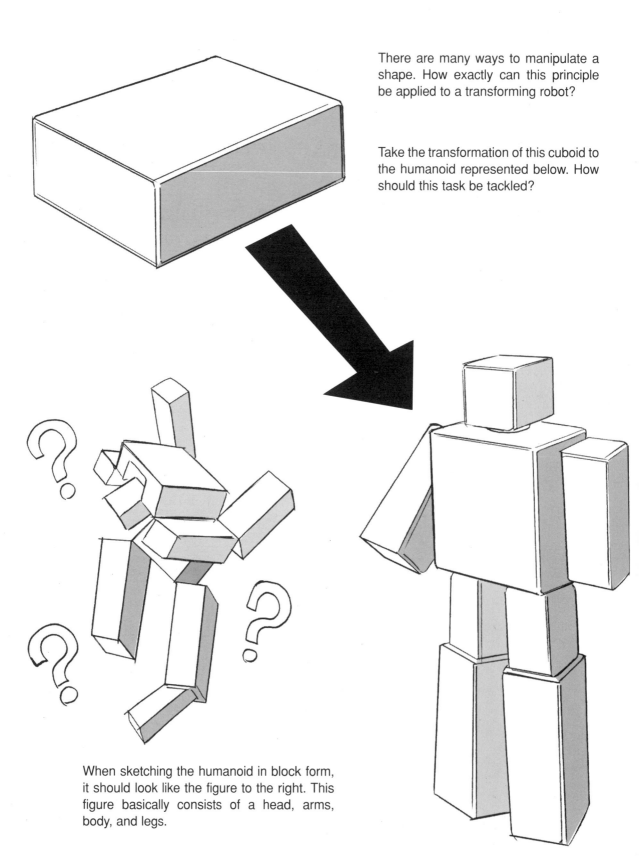

There are many ways to manipulate a shape. How exactly can this principle be applied to a transforming robot?

Take the transformation of this cuboid to the humanoid represented below. How should this task be tackled?

When sketching the humanoid in block form, it should look like the figure to the right. This figure basically consists of a head, arms, body, and legs.

Step 1 Repositioning

Before considering the thickness of the cuboid, let's see how to reposition the flat surfaces.

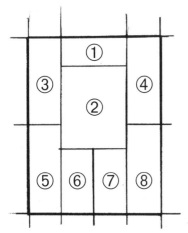

As with the figure on the right, add dividing lines.

① head
② body
③ right arm
④ left arm
⑤ lower-right leg
⑥ upper-right leg
⑦ upper-left leg
⑧ lower-left leg

The repositioning is similar to doing a puzzle.

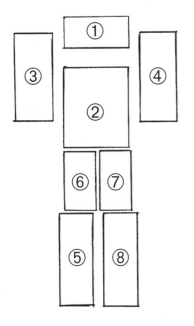

Step 1 Repositioning

The repositioned rectangles are then adjusted to human proportions.

If the arm parts are brought in line with the body then the object takes on an even more realistic human form. Thickness, however, still needs to be looked at.

Seen from side on, the figure should appear like this. At this stage, however, all you have are building blocks.

Visualizing the robot in blocks is ideal for the transformation, but to give it a realistic appearance requires further work. Rotating the head 90° is a step towards a more realistic appearance.

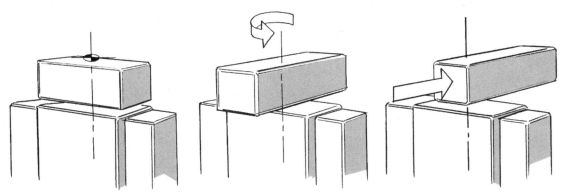

Further improvements come by projecting the hands from the arms and the feet from the legs.

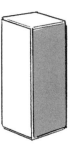 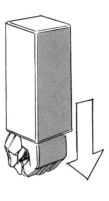 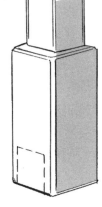 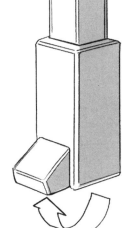

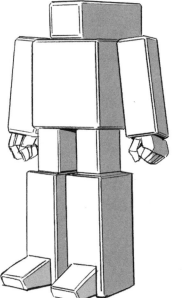

The robot has taken on a more human-like appearance!

Step 2 Depth Awareness

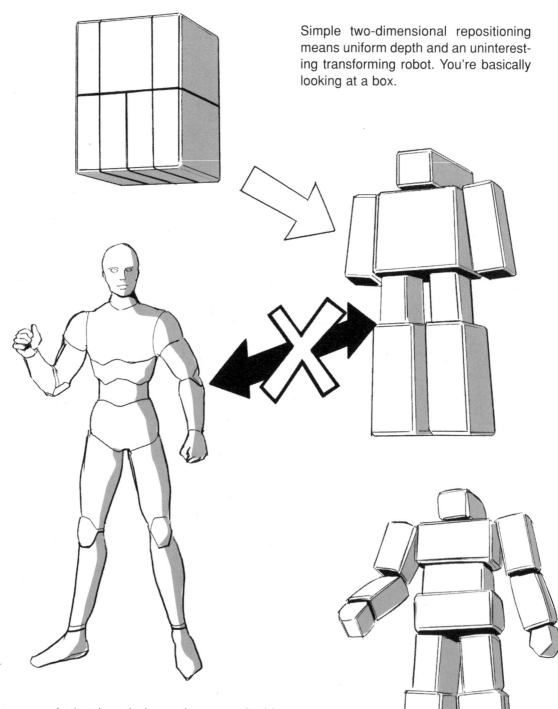

Simple two-dimensional repositioning means uniform depth and an uninteresting transforming robot. You're basically looking at a box.

Let's take a look at a human — in this case an adult male. The chest is thick, the abdomen is well defined and the legs are sturdy. Muscle coverage is well balanced and the long arms and legs are powerful. Our aim is to have the robot become closer to this ideal.

Step 2　Depth Awareness

How can we break away from "boxiness" then? With two-dimensional repositioning, the chest, arms, and legs all have the same depth.

Having the depth of the arms, for example, half that of the other parts seems sensible. Consider the arm block as a single cuboid and draw dividing lines.

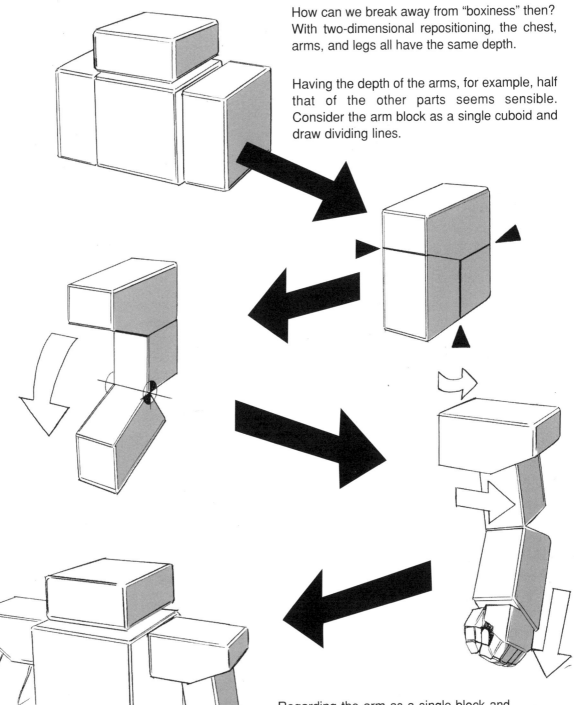

Regarding the arm as a single block and by dividing and repositioning it, allows for a more animated arm.

The legs are handled in the same way as the arms. The leg block is divided lengthwise into four pieces. The two inner pieces form the thighs while the two outer pieces form the lower legs. By just repositioning the legs, however, their depth becomes exactly the same as the body's.

This part will become the backpack of the robot.

The part that will make up the lower leg is cut out. The remaining portion for the upper leg is halved and rotated upwards.

The lower leg is lowered and the foot is swiveled 180°. You've been able to bring about an impressive transformation!

Completed Basic Structure

After dividing the lower from the upper body you repositioned and then the assembled parts (only in concept), it allows the robot to break free from the boxy human look and produces a basic shape. Using this basic shape as the template for adding details and refining the design of the head, the robot is transformed from a box to a humanoid.

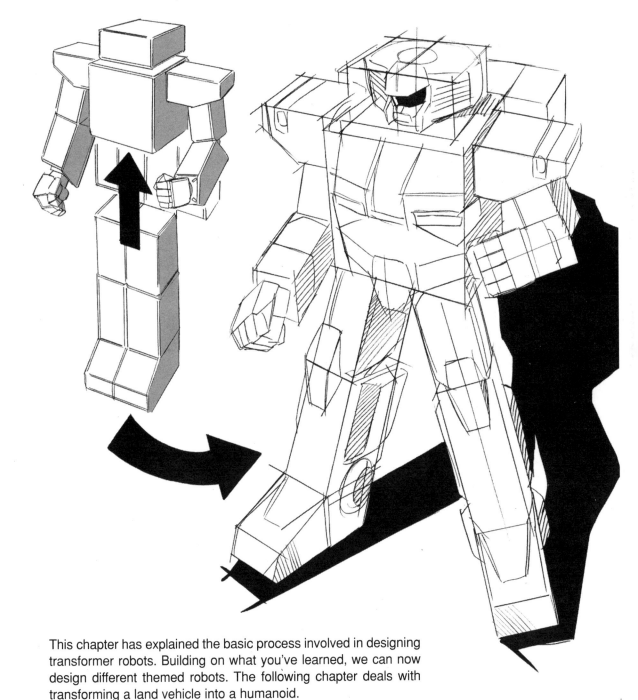

This chapter has explained the basic process involved in designing transformer robots. Building on what you've learned, we can now design different themed robots. The following chapter deals with transforming a land vehicle into a humanoid.

Chapter 3

From Land Vehicle to Robot

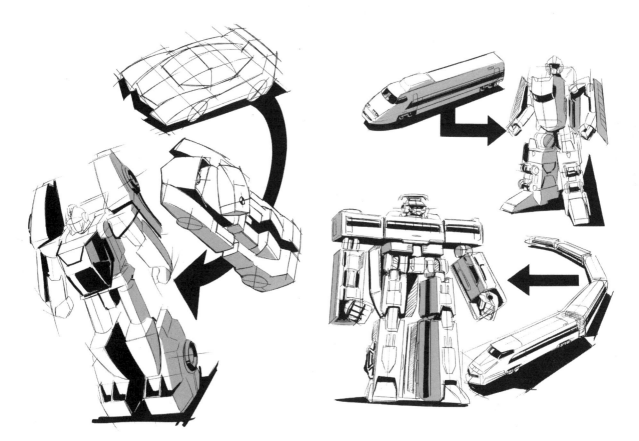

Part 1-1 From Compact Car to Robot

This chapter explains the basic pattern used in transforming
land vehicles (mainly automobiles) into robots.

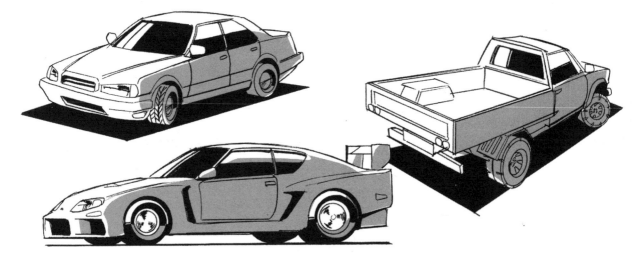

As the above picture shows, vehicles come in a variety of shapes. All of
these vehicles, however, can be regarded as basic cuboids.

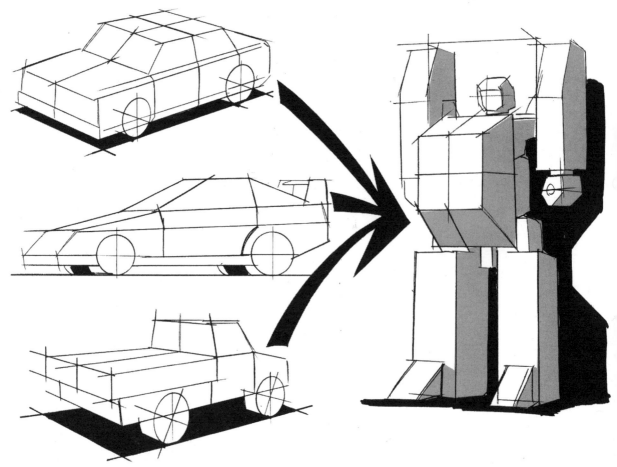

Part 1-1　From Compact Car to Robot

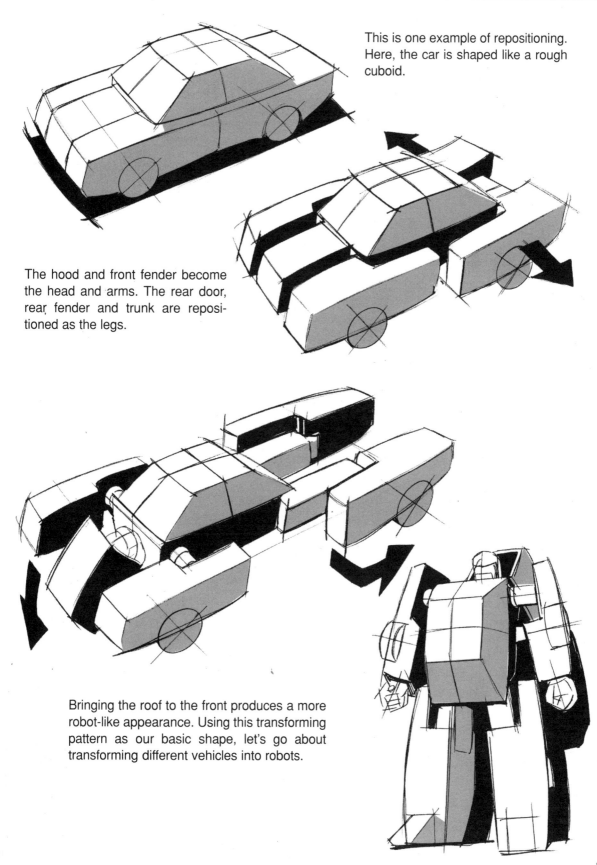

This is one example of repositioning. Here, the car is shaped like a rough cuboid.

The hood and front fender become the head and arms. The rear door, rear fender and trunk are repositioned as the legs.

Bringing the roof to the front produces a more robot-like appearance. Using this transforming pattern as our basic shape, let's go about transforming different vehicles into robots.

Part 1-2 From Large Truck to Robot

The truck transforms according to the same princi-
ples we've covered up until now. The front of the
truck transforms into the head and chest, while the
trailer becomes the arms and legs.

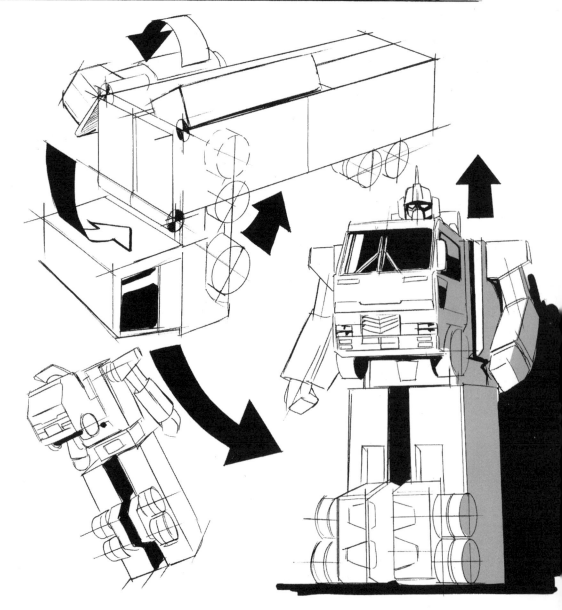

Part 1-3 The Head—Key to the Design

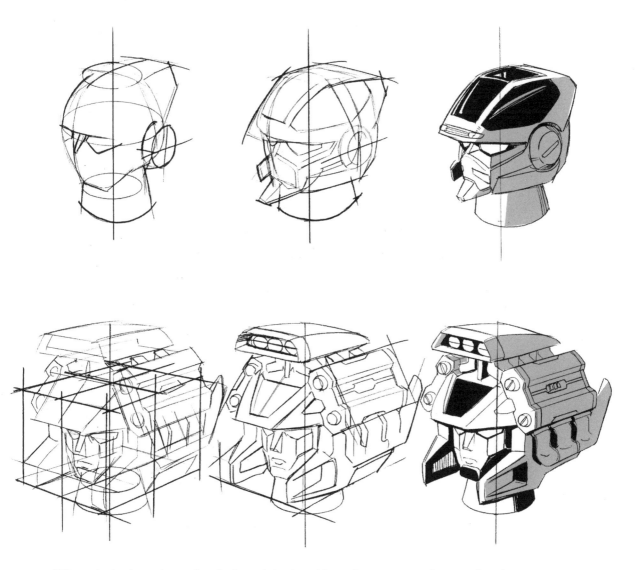

When designing robots, the design of the head is as important as the transforming pattern. The head is vital in expressing the robot's individuality. As it's often the focus of attention, it requires the same amount of detail that goes into the whole robot. Detail does not mean a complex design; it's more of a means to impart the character and the theme of the design.

These two heads are examples of appropriate designs for a transformation from an automobile to robot, or vice versa. The head at the top of the page uses the cabin window to create a sense of speed and style. This type of design would suit a robot transformed from a sports car. The second head, appearing below the first, is built around the heart of the automobile, the engine. By including complex details in the engine, a sense of power is created. The head is based on the premise that the robot has transformed from a large truck or dump truck. This concludes the basic techniques in transforming an automobile and the secret to robot design—the head.

Part 2 takes a closer look at designs suited for different types of vehicles.

Part 2 Sports Cars

Sports cars differ from regular cars in a sense that they ride low, are wide, have large wheels and a wing. These characteristics should be skillfully interwoven into the design of the robot.

First, a rough design of a sports car is made. Applying the basic shapes, the transformation plan is devised and repositioning is considered. When the robot stands up the large rear wing, a characteristic of a sports car, comes in handy as the ankles.

Part 2 　 Sports Cars

When the overall transformation plan has been decided on, the details are then filled in.

Taking into consideration the overall shape, details of sport cars are added. These include compact headlights, radiator slits to cool the large, midship-mounted engine, the rear windows, and rear fender.

Part 2 Sports Cars

Take another moment to reconsider the transformation process. On the previous page we decided to design a sports car. Can this sports car now be easily transformed into a robot?

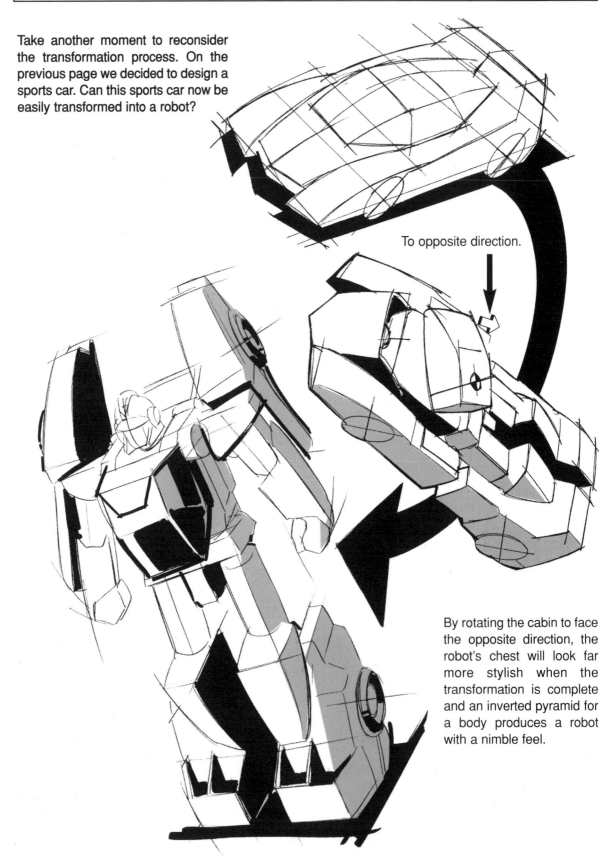

To opposite direction.

By rotating the cabin to face the opposite direction, the robot's chest will look far more stylish when the transformation is complete and an inverted pyramid for a body produces a robot with a nimble feel.

Part 2　Sports Cars

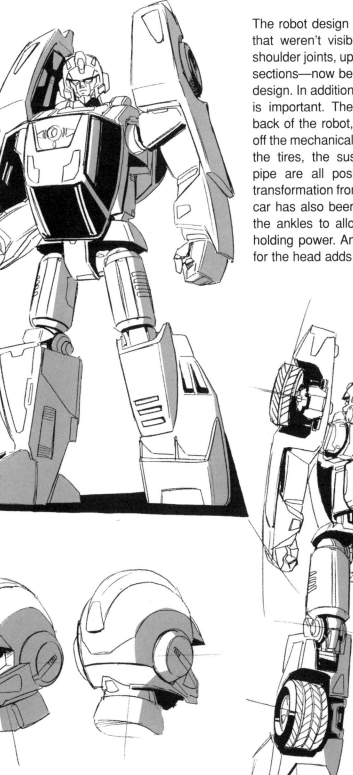

The robot design is now complete. The parts that weren't visible while in car mode—the shoulder joints, upper legs, fists, the leg cross-sections—now become the high points of the design. In addition to this the back of the robot is important. The chassis, which forms the back of the robot, and the attached hood set off the mechanical details. The tread pattern of the tires, the suspension, and the exhaust pipe are all positioned appropriately for a transformation from a car. The rear wing of the car has also been repositioned effectively as the ankles to allow the legs to exude road-holding power. An open-faced helmet design for the head adds to the sporty look.

Part 2　Sports Cars

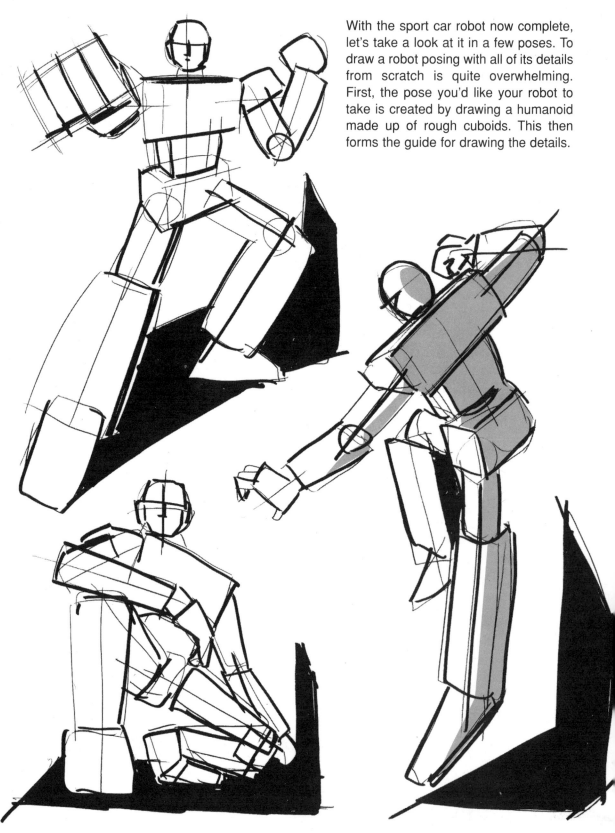

With the sport car robot now complete, let's take a look at it in a few poses. To draw a robot posing with all of its details from scratch is quite overwhelming. First, the pose you'd like your robot to take is created by drawing a humanoid made up of rough cuboids. This then forms the guide for drawing the details.

Part 2　Sports Cars

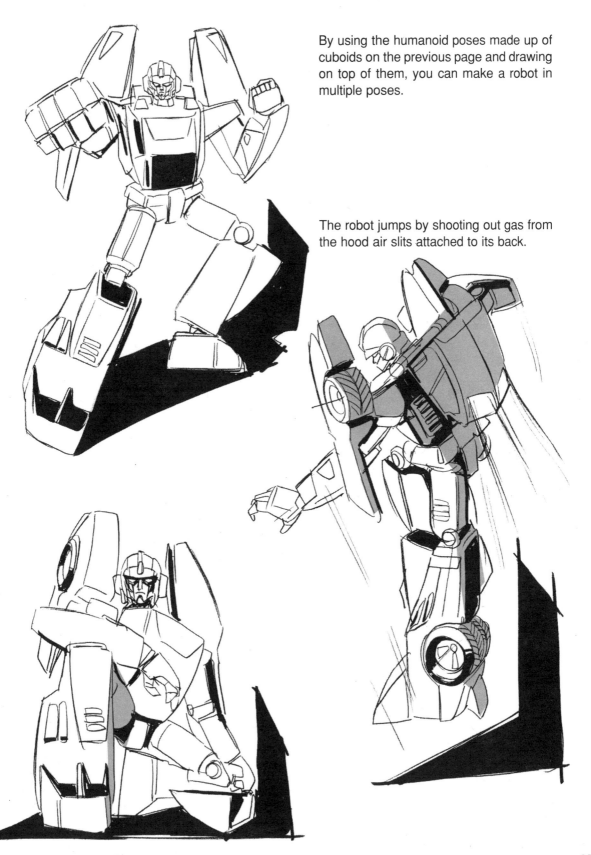

By using the humanoid poses made up of cuboids on the previous page and drawing on top of them, you can make a robot in multiple poses.

The robot jumps by shooting out gas from the hood air slits attached to its back.

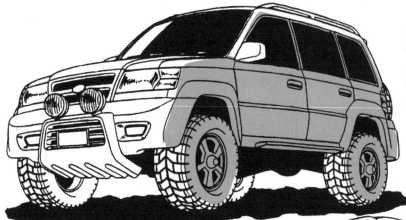

Commonly known as a 2-box car, the 4WD is characterized without a trunk hood, its tall height, large off-road tires and a spare tire attached to the rear.

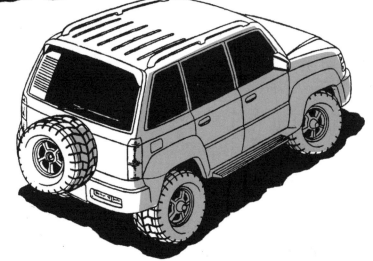

Let's actively use the spare tire and other features of the 4WD in the transformation.

The large patterned tires are definitely an eye catcher.

Part 3 4WD

With the basic shape of the transformation in mind, let's go about designing a plan for the transformation. In contrast to a sports car, the hood is repositioned to become the legs of the robot. In doing this the spare tire at the rear can be easily used as the head.

90°

90°

The head of the robot conveys a lot of information, so by using a key characteristic of a 4WD—the spare tire, we're able to keep the 4WD feel even after the transformation.

180°

180°

The cabin parts in the middle allow the arms to be positioned.

This transformation plan looks like a definite goer!

Part 3 4WD

Based on the transformation plan, the lines are tidied up and the details are drawn in.

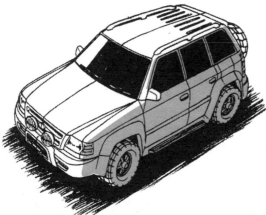

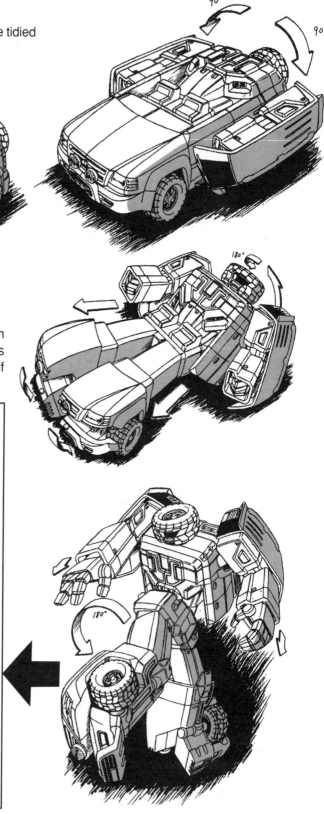

Having the front grill and bumper in contact with the ground doesn't exactly convey stability. This can be overcome by dividing the bumper in half to form toes.

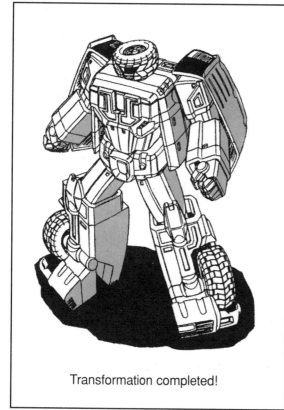

Transformation completed!

Part 3 4WD

The design is complete.

The head is characterized by the tire pattern.

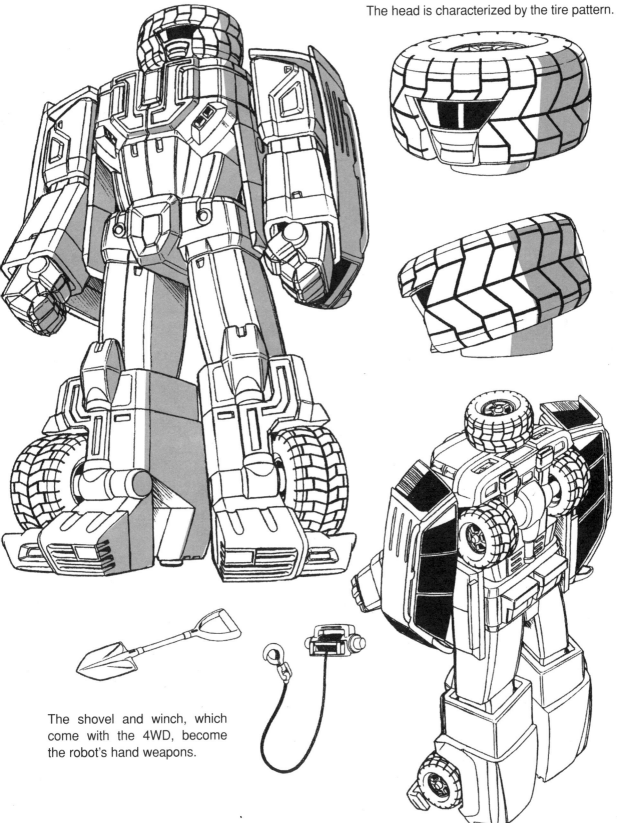

The shovel and winch, which come with the 4WD, become the robot's hand weapons.

The robot's wrist, the "manipulator"

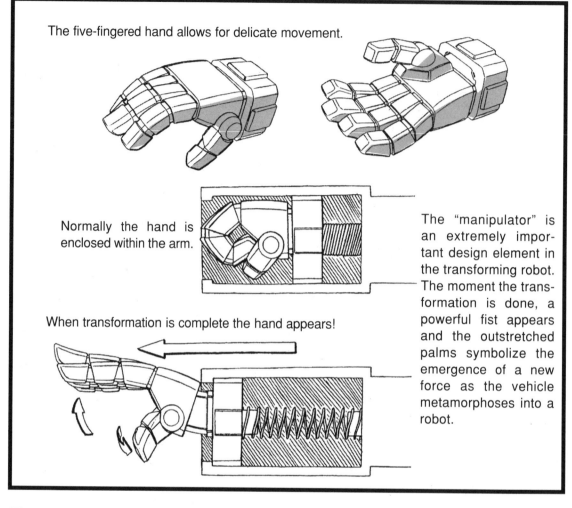

The five-fingered hand allows for delicate movement.

Normally the hand is enclosed within the arm.

When transformation is complete the hand appears!

The "manipulator" is an extremely important design element in the transforming robot. The moment the transformation is done, a powerful fist appears and the outstretched palms symbolize the emergence of a new force as the vehicle metamorphoses into a robot.

Types of manipulators

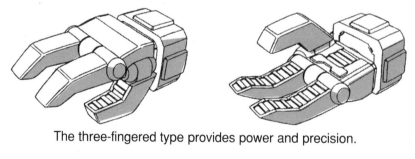

The three-fingered type provides power and precision.

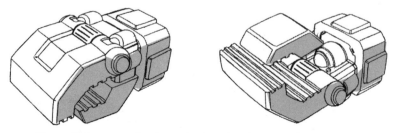

The mitt type emphasizes destructive force and raw power.

Part 3 4WD

Action poses

Take a look at this collection of earth-shattering 4WD robot poses.

Part 4　Trucks

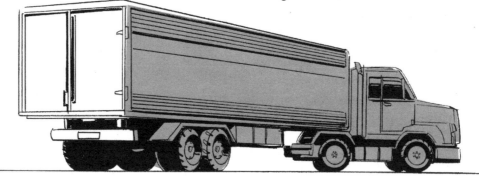

One of the most characteristic facets of a large truck is the cabin and attached trailer.

Making use of this feature, the cabin and trailer transform separately and then reunit as a giant robot.

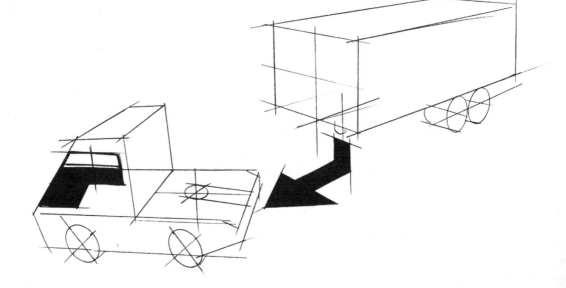

With the basic shape in mind, a rough transformation plan is drawn. The cabin becomes the head and chest and the rear wheels are flipped up to make things compact.

The immense capacity of the trailer offers a large surface area, in turn creating a strong boxiness. By simply opening the trailer we can reveal the arms and the part that allows for connection to the cabin.

Let's take a look at the trailer in terms of the front and rear. The rear is divided into two parts to form thick, solid legs. The interior and exterior of the front of the trailer are turned inside out, releasing the arms inside and creating a space to allow for the melding of the head to the body. With this plan the transformation is close to reality.

Part 4　Trucks

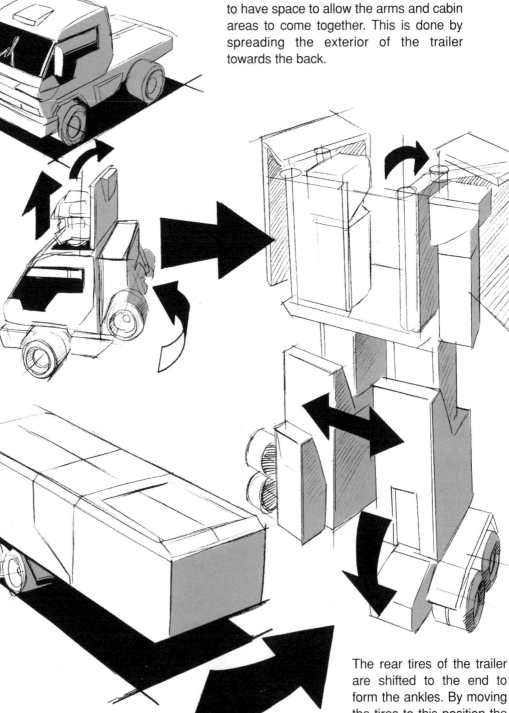

A little more work is needed if the trailer is to have space to allow the arms and cabin areas to come together. This is done by spreading the exterior of the trailer towards the back.

The rear tires of the trailer are shifted to the end to form the ankles. By moving the tires to this position the robot can glide along as if using inline skates.

Part 4 Trucks

The design is done! The exterior of the trailer now acts as armor, reaching from the shoulder to the arms to create an intimidating and powerful robot. The front grill of the cabin serves as the chest of the robot, bringing to the design a distinct truck flavor.

Part 4　Trucks

As with the previous robot, a truck robot with its massive arms and legs makes it quite difficult to draw in various poses. With careful thought to the joints, however, this problem can be overcome.

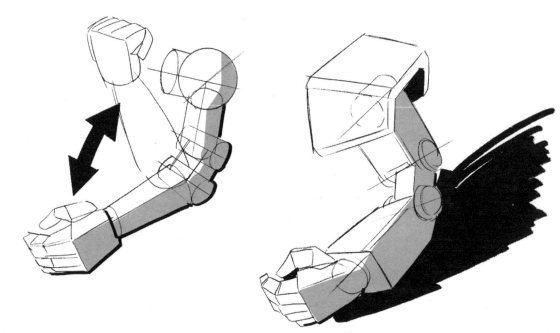

The flexibility of the human body allows for thick arms and legs with a single pivot point to bend and give with the least amount of trouble. In the case of hard steel robots, however, no such flexibility exists. So to allow these thick arms and legs to move, two joints are needed. By giving the robot such joints, it is able to pose with little difficulty.

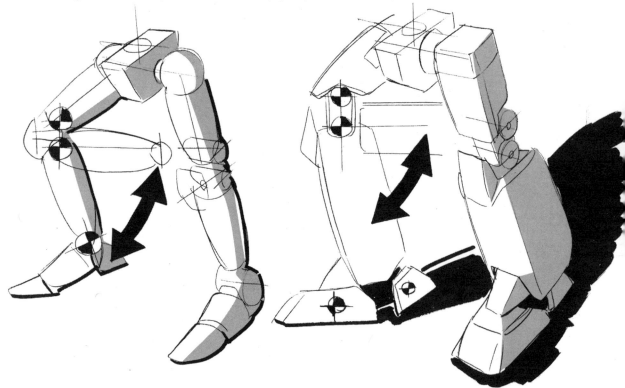

Part 4 Trucks

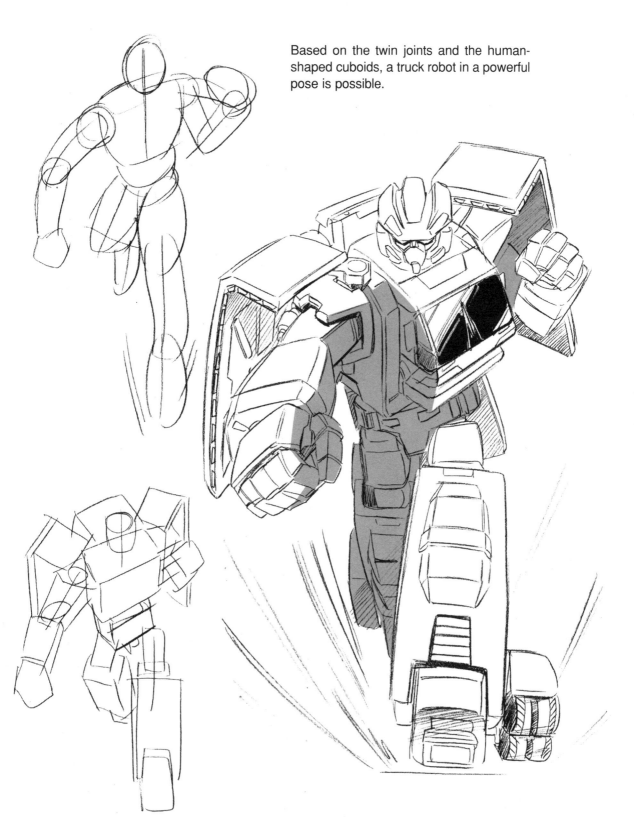

Based on the twin joints and the human-shaped cuboids, a truck robot in a powerful pose is possible.

Part 5　Bulldozers

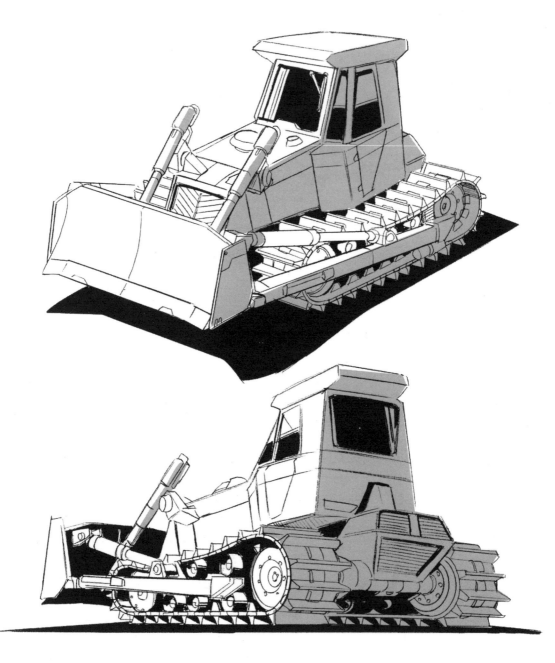

The distinctive crawler track of a bulldozer makes it a vehicle familiar to just about everyone. The bulldozer blade is characterized by its hydraulic power and vertically mobile shape. In combination with additional unique features, it gives this vehicle a very mechanical look, making it a popular choice for transforming robot designs.

Part 5　Bulldozers

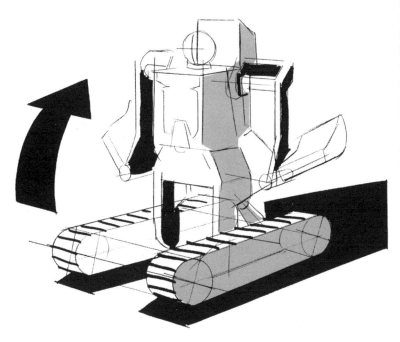

Let's lay out a plan for transforming a bulldozer into a robot. The most distinguishing feature of a bulldozer is its crawler track. The crawlers function to increase the surface area in contact with the ground, allowing the vehicle to move across irregular and inclined surfaces with no loss of power. A striking design will result from taking advantage of these crawlers and turning them into the legs of the robot.

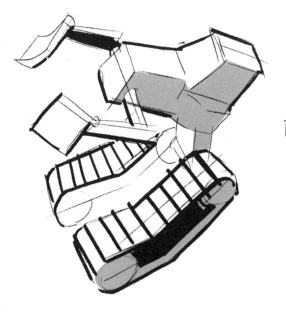

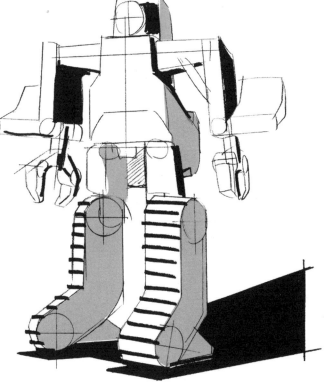

Part 5 Bulldozers

Now let's decide on the transformation plan. First, leave the crawlers as they are and flip up the body section so that its underside is facing forward. The mounting arms of the blade can easily become the arms of the robot. Divide the blade into two sections and spread them toward the shoulders. Then open the front radiator grille and push out the head section.

Part 5　Bulldozers

Here is the completed robot based on our transformation mechanism. The legs, made solely from the crawlers, give the robot an eye-catching form.

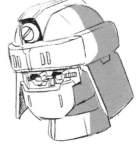

Part 5　Bulldozers

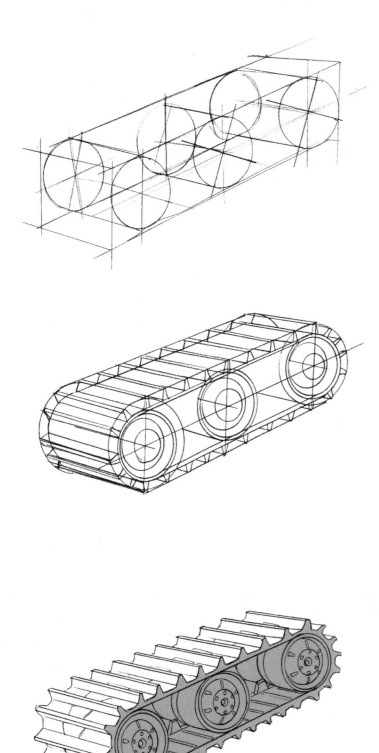

Bulldozers, tanks (see Part 6), and othe
large vehicles are often equipped with
crawler tracks—also known as caterpilla
tracks. Drawing these crawlers well is no
easy task. Here are some tips to help
you.

In your drawing, think of the area occu
pied by the crawler as a long box (hexa
hedron). Draw ellipses on the side facing
front, imagining the drive wheels com
pletely filling the space from top to bot
tom. Use an ellipse ruler with an angle
matching that particular side to help you
draw it perfectly. Here, we've drawn a
sixty degree ellipse tilted fifteen degrees
from perpendicular. You will then draw
ellipses on the opposite, corresponding
side. Once you join the left side to the
right, you will have three wheels inside a
long box.

Now we'll draw the track around the
drive wheels. A large ellipse, with a
diameter greater than the wheels we just
drew, must be drawn around the first
and last wheels. This ellipse will provide
the track with sprocket ribs and thick-
ness.

Next, we'll draw the ribs. The ribs on the
upper and lower sides stand perpendi-
cular to the track at all times. Where the
ribs catch, make sure to always draw
them pointing toward the axle of the
sprocket wheel.

After you connect both sides of the ribs,
add details to the track, put screws on
the wheels, and erase all the guidelines.
Now, you have a completed crawler.
This method can be applied to draw any
kind of crawler track. It is, however, the
most difficult part to draw, and requires a
good amount of practice to get it right.

Part 5 Bulldozers

Let's pose and draw our bulldozer robot wielding a light saber.

Robots tend to be put in stiff, "robot-like" poses. Robocop is one example of this style. In contrast, Japanese manga are known for depicting complex-looking robots in humanlike poses. Perhaps it's this contradiction that makes Japanese manga so interesting.

As seen in the drawing above, we can first pose a human wielding a sword, then use that as a guide to draw a robot. Robots aren't as flexible as humans, but by bending, shifting and tilting the various blocks in addition to adjusting the directions of the joints, we can step-by-step create our desired pose.

Part 6　Tanks

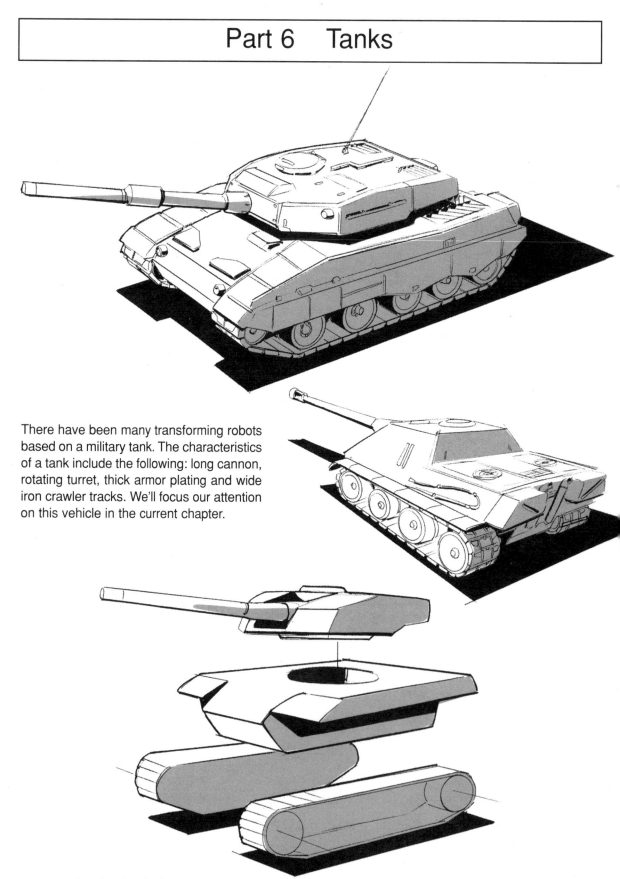

There have been many transforming robots based on a military tank. The characteristics of a tank include the following: long cannon, rotating turret, thick armor plating and wide iron crawler tracks. We'll focus our attention on this vehicle in the current chapter.

A tank is basically made up of three sections: cannon/turret, body and crawler tracks. With this in mind, let's assign a body part to each section to make the transformation possible.

Part 6 Tanks

Since we are transforming a tank, our design should reflect a sense of "strength" and "size."

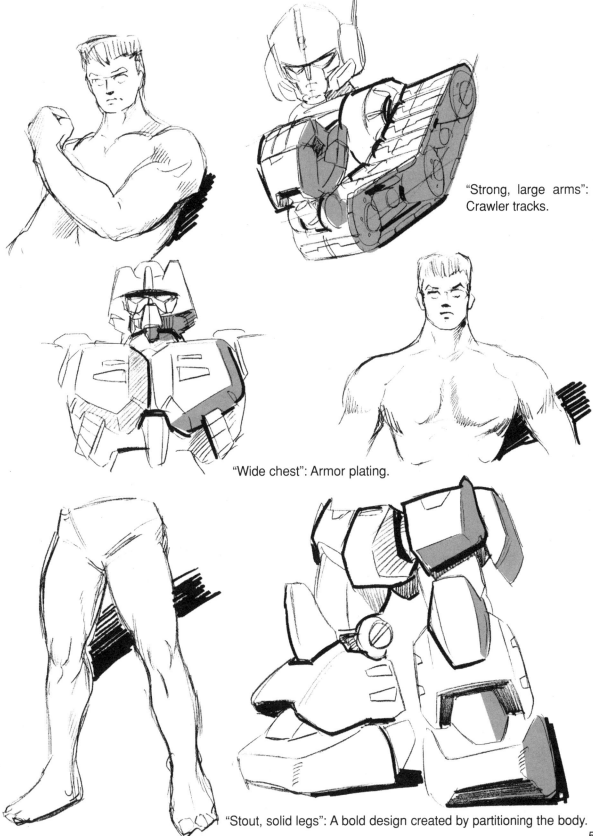

"Strong, large arms": Crawler tracks.

"Wide chest": Armor plating.

"Stout, solid legs": A bold design created by partitioning the body.

Part 6　Tanks

Now we'll turn our attention to the transforming mechanism. The crawler tracks will become the arms. The front portion of the body will become the legs. Once the body is opened up to form the legs, the robot will stand with the turret's top surface facing behind.

Adjust the positioning of the legs and turn the entire body to face forward. Take out the head from the rear part of the body, turn the turret (which was pointed straight down) to face upward and voilà—the transformation is complete.

Part 6 Tanks

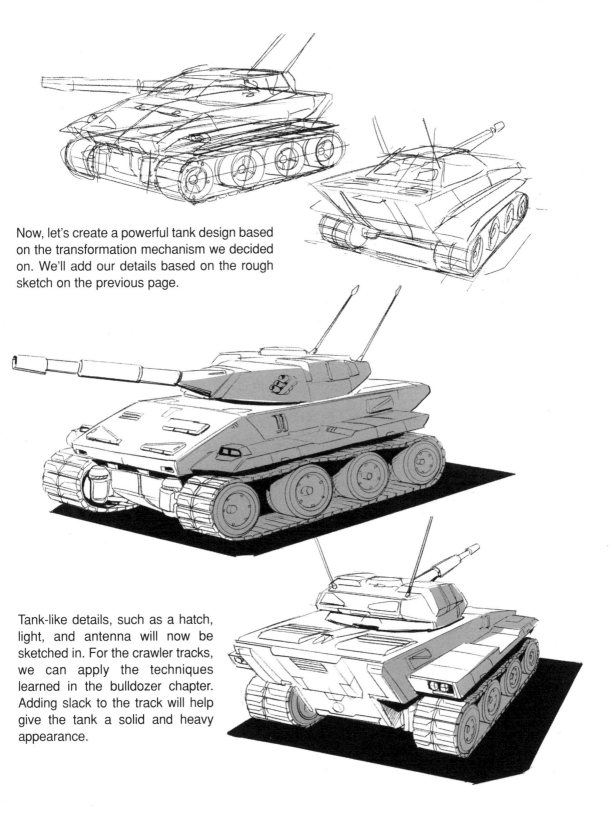

Now, let's create a powerful tank design based on the transformation mechanism we decided on. We'll add our details based on the rough sketch on the previous page.

Tank-like details, such as a hatch, light, and antenna will now be sketched in. For the crawler tracks, we can apply the techniques learned in the bulldozer chapter. Adding slack to the track will help give the tank a solid and heavy appearance.

Part 6 Tanks

We'll draw the form of the robot based on the tank design. The arm section is made from the crawler tracks and has a powerful look. The bulldozer robot in the previous chapter also incorporated crawler tracks, but this robot presents a completely different image. In this way, many different transforming robot designs can be created and drawn by assigning sections differently depending on the vehicle type.

The design of the head was based on a tanker man's helmet. One eye is equipped with an alignment display unit, enhancing the tank-like qualities of the robot.

Part 6　Tanks

Next, we'll design the weaponry equipping our robot. Heavy firearms usually take on a cylindrical shape.

After deciding on the heavy firearm's general composition and form, we'll draw it in side view.

Once we've got our side view, we'll use it to draw the weapon from a different angle. The side view sketch will allow you to get a perspective on its overall balance, greatly facilitating the drawing process.

You can design all sorts of firearms by applying these techniques to your drawings.

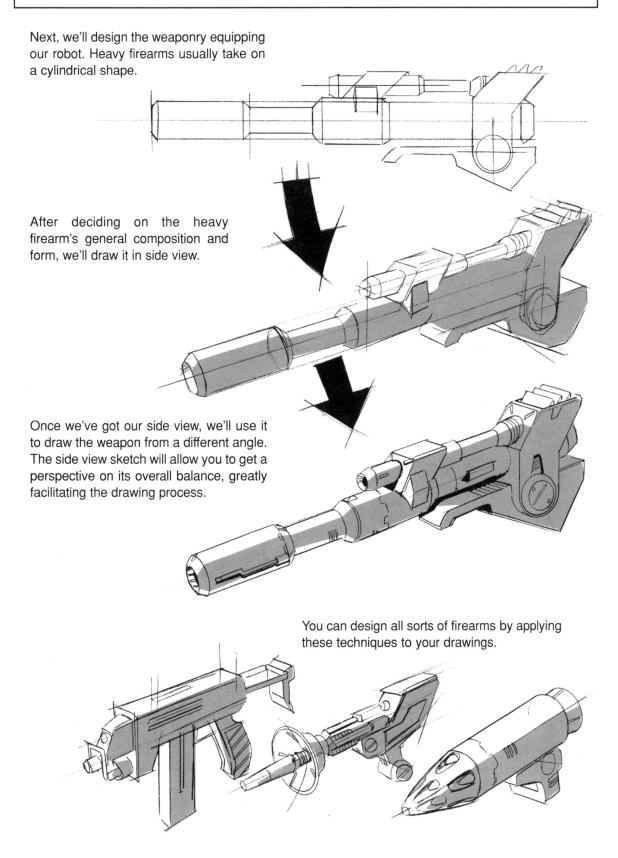

Part 7 Trains

What's a large land vehicle that is familiar to most anyone? A train, of course!

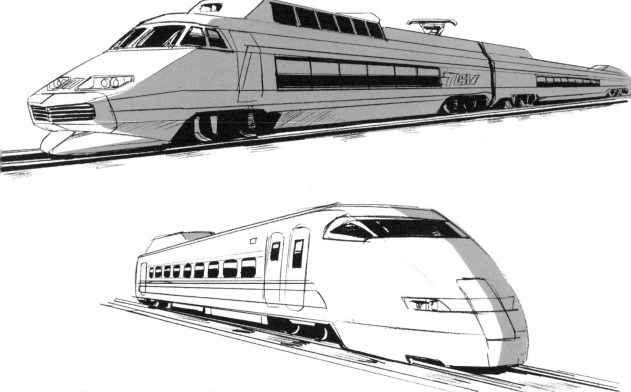

Trains take on many different forms. In general, they are comprised of several cars, with the most characteristic features of the train mostly visible in the lead coach. Express trains in particular have been a popular design for transforming robots. It appears that the design is popular with kids—or kids at heart—all around the world!

Another popular design is the mighty locomotive engine, with its strength to tow numerous freight cars. A locomotive differs from a normal train in that the freight cars in tow possess no propulsive power of their own. Instead, the entire body of the locomotive itself functions as the engine. Both types of railway vehicles are characterized by having a long, slender body.

Part 7 Trains

If we wanted to transform only the lead coach, we could probably apply
the same patterns used earlier in the truck robot. This method would
result in a very similar design—been there, done that.

Instead, let's go for a bolder design that transforms
the entire length of the train and all of its features
into one giant robot!

Part 7　Trains

Now for the transformation! Each car must be assigned to become a part of the robot's body; one each for the right leg, right arm, body, left arm and left leg. It's already starting to look a bit like a robot, isn't it?

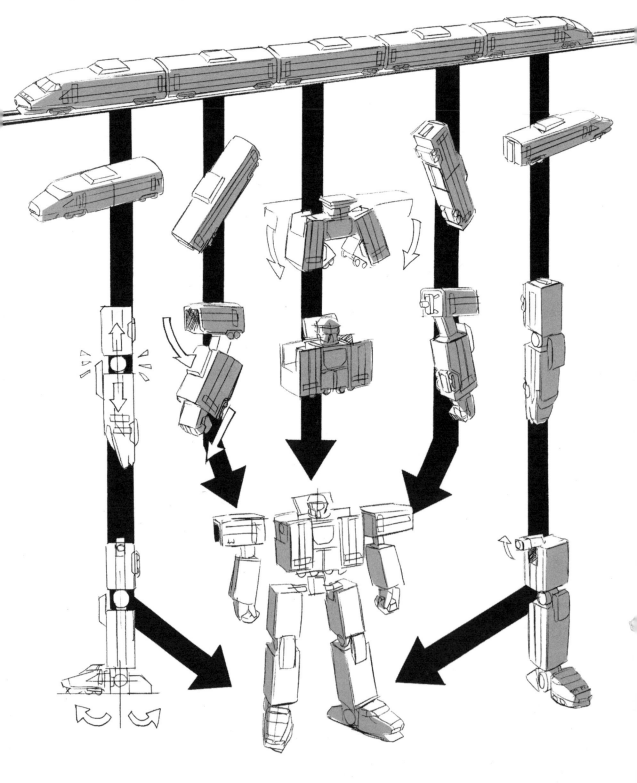

Part 7 Trains

Here is a completed transforming robot designed using the French TGV express train. It is a clear departure from the robot designs of the previous chapters. The space normally occupied by one complete robot (one train car) is used in its entirety as just one portion of this robot, giving the piece an air of enormity. Also, characteristics inherent in the train motif make the design identical on both sides, tending to give the robot an overall uniformity in appearance. However, this can be altered by designing a robot that incorporates shifted orientations of the cars.

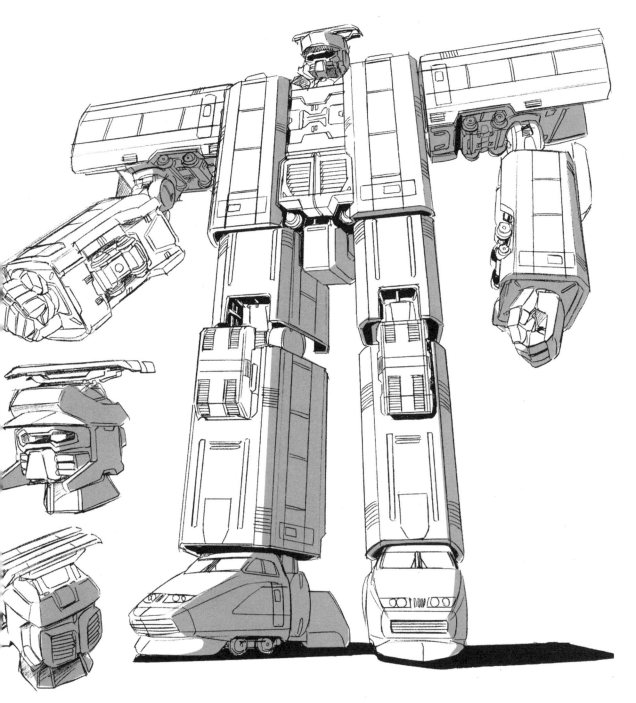

Now, let's pose the completed robot like a human.

Once you've settled on the pose, use this as a guide for drawing in the details. Having two joints in the thick arms and legs allows for flexibility and strength.

Here we have the completed powerful pose of the huge robot carrying a giant gun.

Part 7 Trains

We've gone one step further to create an action pose! Yes, the giant TGV robot is flying, thanks to the big booster rockets that can be seen on its back. This kind of dynamic detail can be incorporated if you are going for a more fanciful robot design.

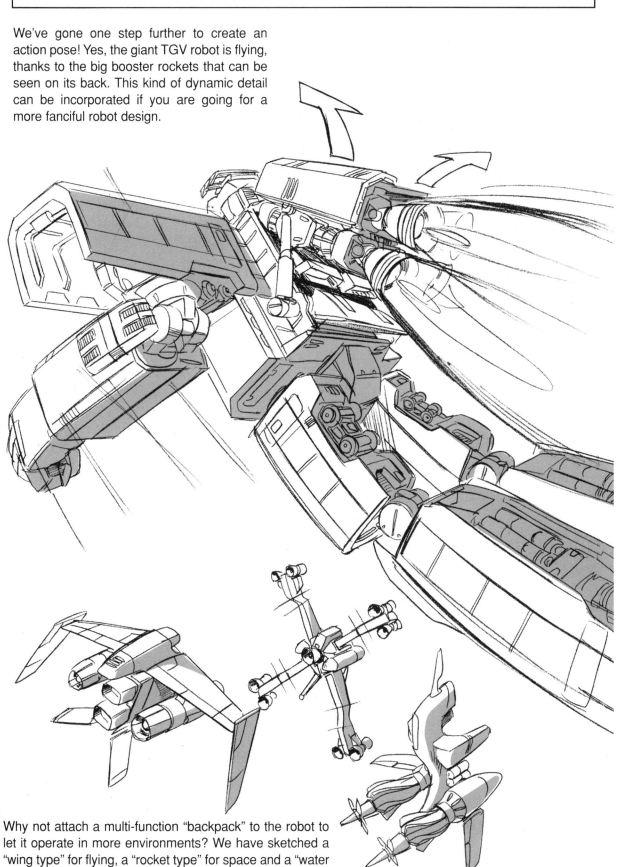

Why not attach a multi-function "backpack" to the robot to let it operate in more environments? We have sketched a "wing type" for flying, a "rocket type" for space and a "water screw type" for aquatic environments.

Examples of Transforming Robots

On this page, we'll introduce a commercially available transforming robot by PLEX.

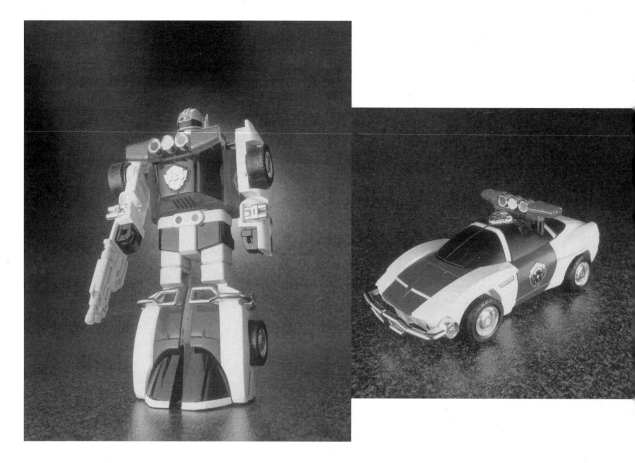

The example we present here is the **DELUXE ROBO RACER**, a car to robot transformer that was featured in POWER RANGERS TURBO. It's a futuristic sports-car-style police cruiser that makes an awesome transformation into a robot. PLEX's designs are based on the philosophy that the transforming mechanism should always hold true, even when made into a three-dimensional model like this one.

First, the hood of the DELUXE ROBO RACER folds up to reveal the robot's head. Next, the front fender moves toward the arms and the rear portion of the body folds along the rear bumper hinge. The waist then rotates 180 degrees lengthwise on the axle to form the massive legs. Notice how the patrol light was designed to end up on the robot's chest section.

We mostly focused on motor vehicles in this chapter. In the next chapter, we'll move on to cover vehicles of the sky. That's right, aircraft!

Chapter 4

From Aircraft to Robot

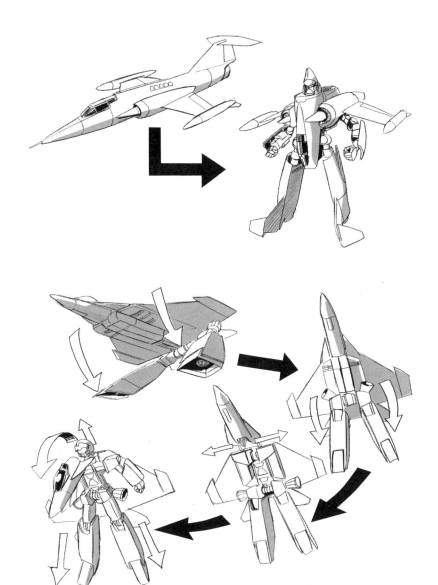

Part 1 From Aircraft to Robot

We'll now examine the basic scheme for transforming an airplane into a robot.

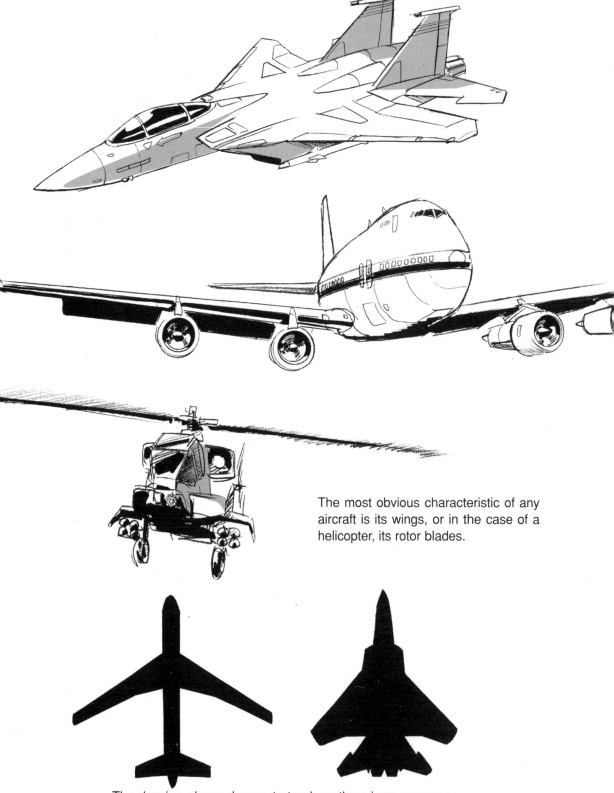

The most obvious characteristic of any aircraft is its wings, or in the case of a helicopter, its rotor blades.

The drawing above demonstrates how the wings occupy a proportionately large area in relation to the fuselage.

Part 1 From Aircraft to Robot

We'll use a typical fighter jet as our example.

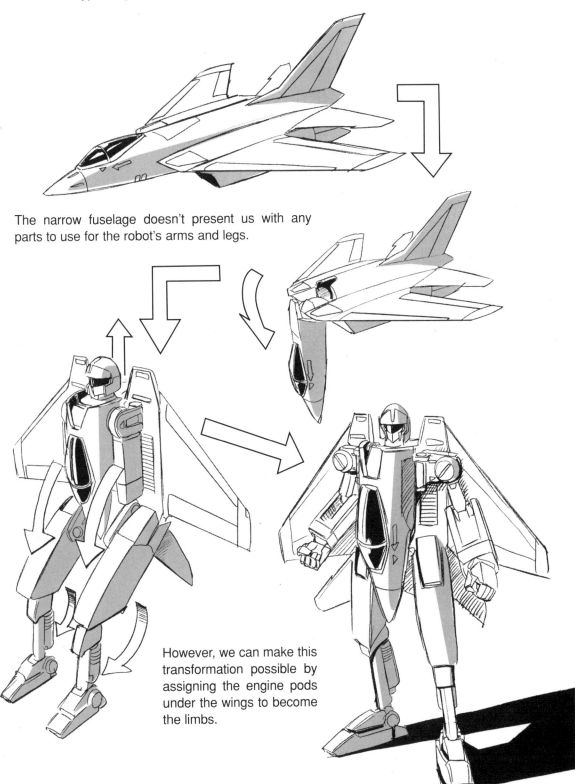

The narrow fuselage doesn't present us with any parts to use for the robot's arms and legs.

However, we can make this transformation possible by assigning the engine pods under the wings to become the limbs.

Part 1　From Aircraft to Robot

Let's try transforming a bigger airplane. This aircraft presents us with a larger fuselage and many other features that serve various functions.

You can develop many different robot variations by creatively taking advantage of each aircraft's unique features.

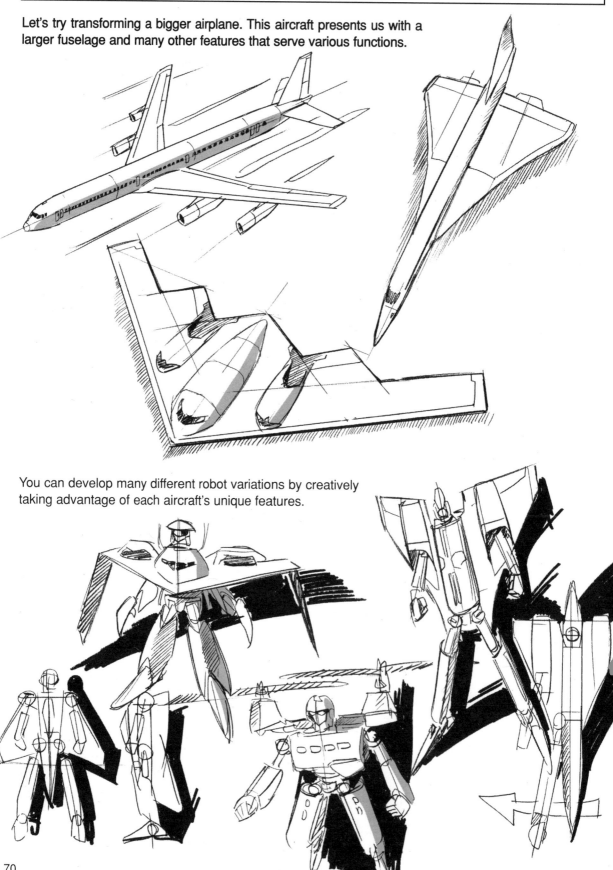

Part 1　From Aircraft to Robot

A clever wing transformation mechanism will allow the robot form to use them for flight as well.

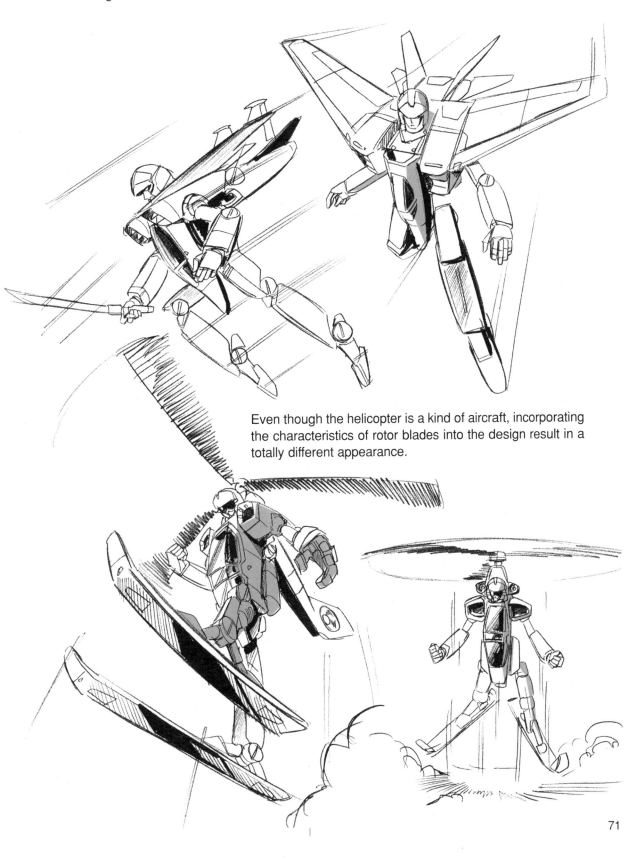

Even though the helicopter is a kind of aircraft, incorporating the characteristics of rotor blades into the design result in a totally different appearance.

Part 2 Small Fighter Plane

Many popular transforming robot designs are based on the small fighter plane.

One can find a wide variety of fighter planes in the skies.

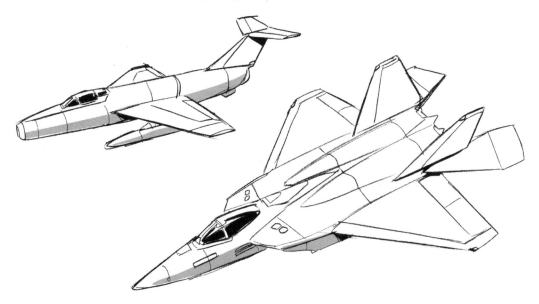

The shape of the fighter plane has evolved considerably over the years. This chapter focuses on a design based on the small fighter plane of the near future.

Part 2　Small Fighter Plane

The narrow fuselage of the classic small fighter plane doesn't provide us with many options for parts that can convert into the robot's limbs.

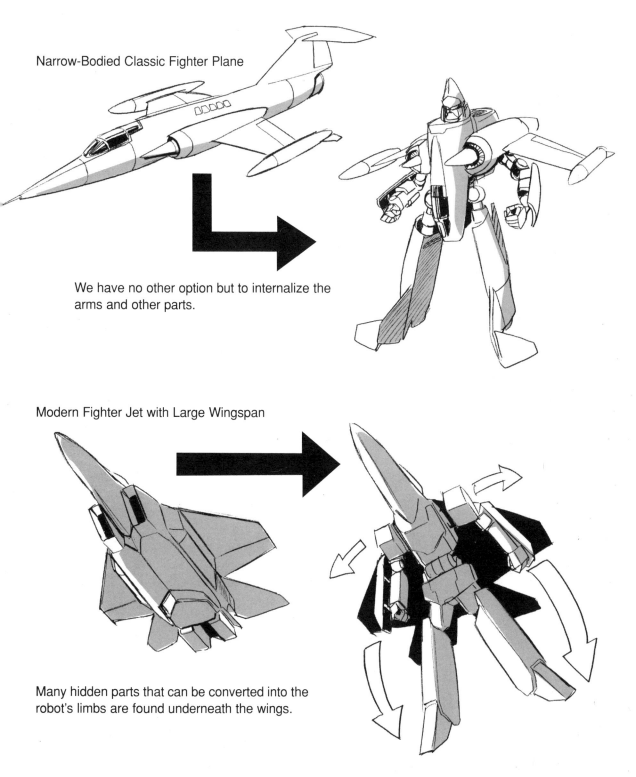

Narrow-Bodied Classic Fighter Plane

We have no other option but to internalize the arms and other parts.

Modern Fighter Jet with Large Wingspan

Many hidden parts that can be converted into the robot's limbs are found underneath the wings.

Part 2 Small Fighter Plane

Let's think of a transformation mechanism suitable for the small fighter plane of the near future.

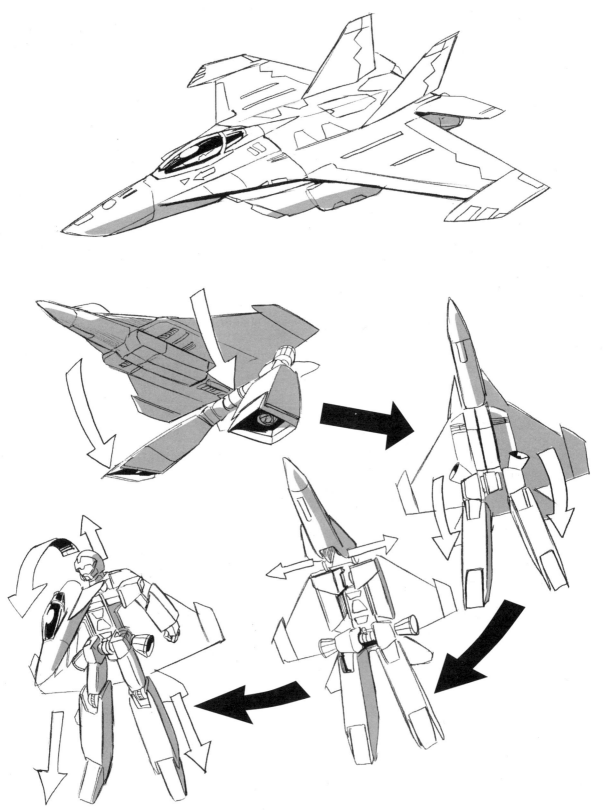

Part 2　Small Fighter Plane

This is the completed transformation. The engine nozzles were positioned on the waist for flight propulsion use. Notice how the wings were shifted to the back, retaining an aircraft-like image. The center of the body folds and the cockpit area becomes the robot's chest. Furthermore, the body's fold reveals the robot's head, designed to resemble a pilot's helmet.

Part 2　Small Fighter Plane

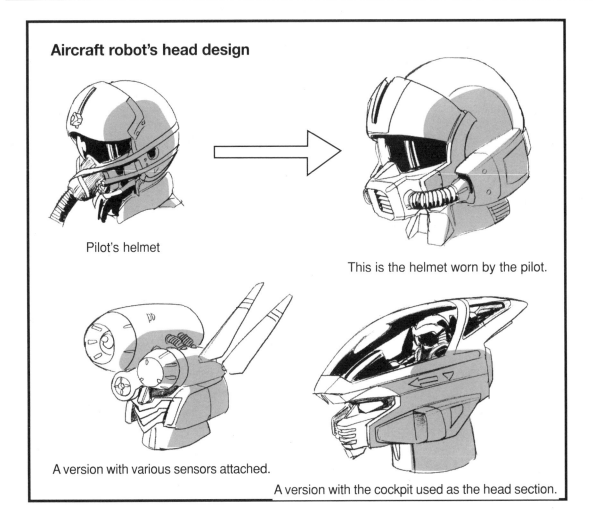

Aircraft robot's head design

Pilot's helmet

This is the helmet worn by the pilot.

A version with various sensors attached.

A version with the cockpit used as the head section.

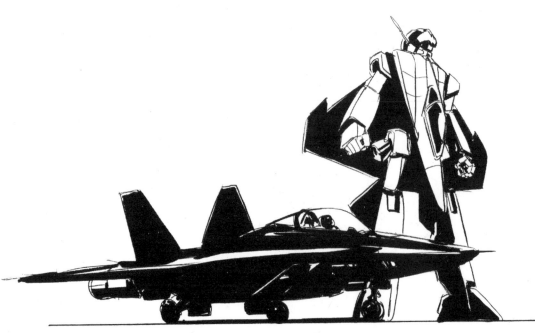

Part 2 Small Fighter Plane

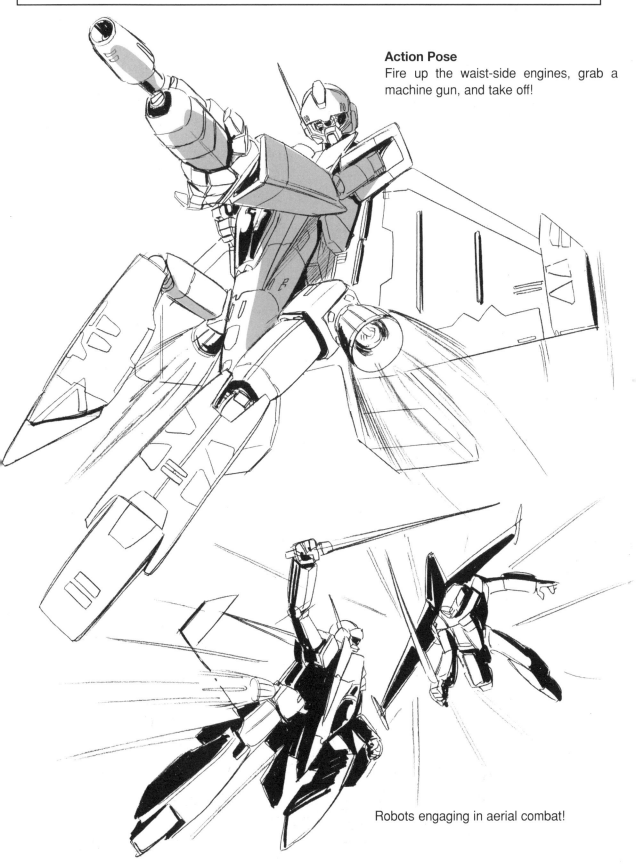

Action Pose
Fire up the waist-side engines, grab a machine gun, and take off!

Robots engaging in aerial combat!

Part 3 Midsize Attack Plane

The midsize attack plane is like a larger version of the small attack plane, but with a fuselage that can carry a large amount of ammunition.

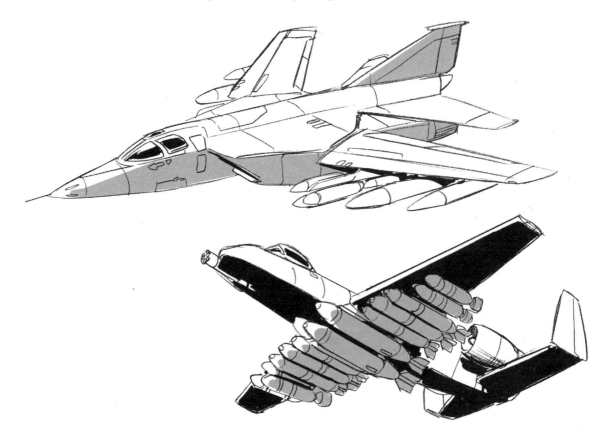

That's why the numerous missiles and other ordnance hanging underneath its body characterize this plane.

An attack plane carries tons of weaponry—a heavy load to handle, especially during takeoff.

Part 3 Midsize Attack Plane

The midsize attack plane bristles with weaponry. We want our robot to retain this weaponry after the transformation.

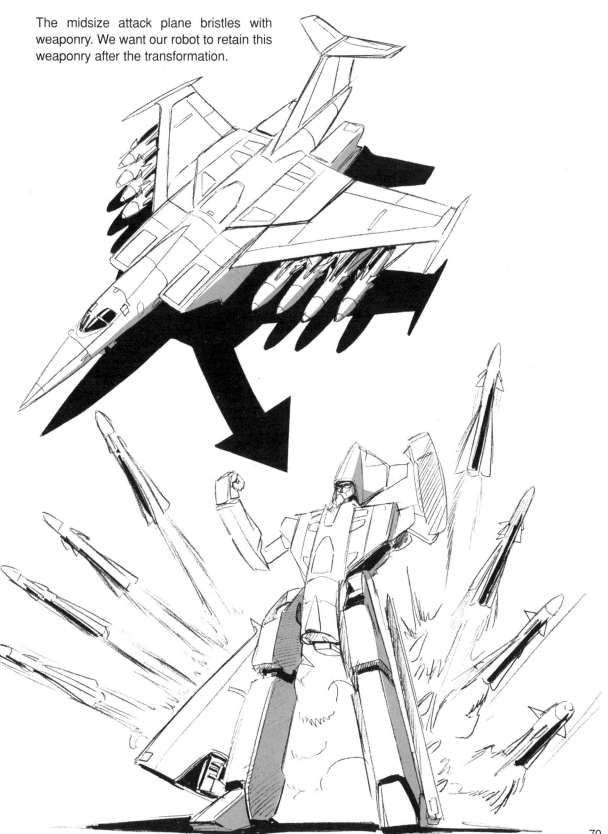

Part 3 Midsize Attack Plane

Let's consider our transformation mechanism. We'll use a method that allows the missiles under the wings to become weapons on the robot's leg sections.

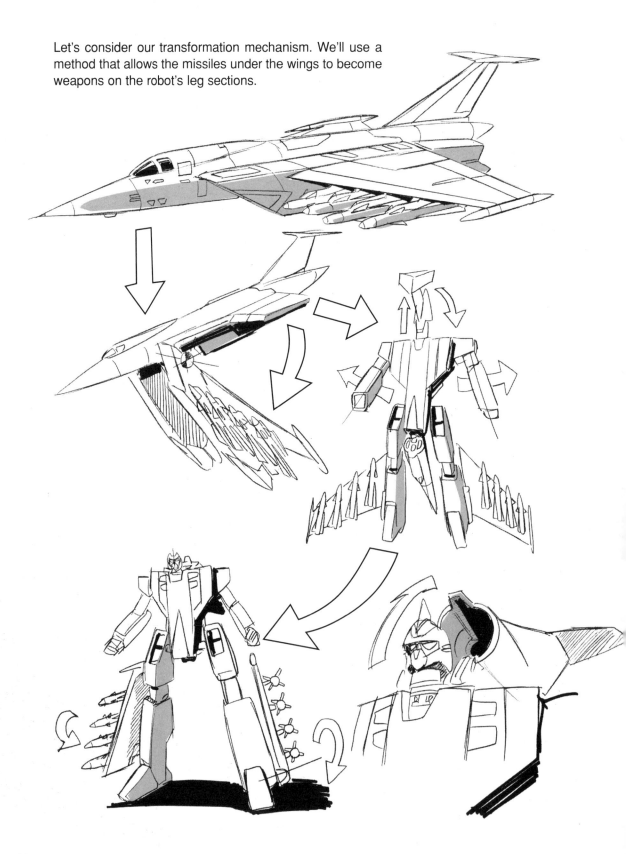

The completed transformation

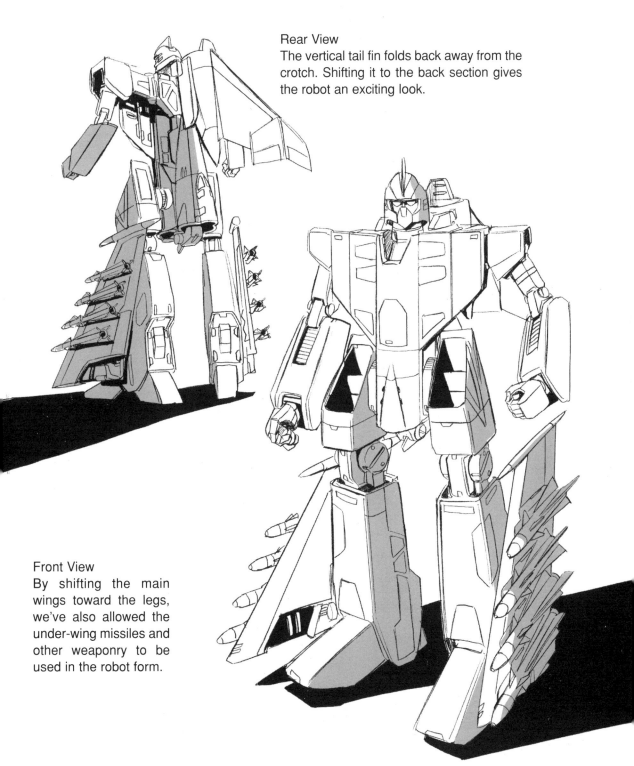

Rear View
The vertical tail fin folds back away from the crotch. Shifting it to the back section gives the robot an exciting look.

Front View
By shifting the main wings toward the legs, we've also allowed the under-wing missiles and other weaponry to be used in the robot form.

Part 3　Midsize Attack Plane

Aircraft Engine

Basically, the air taken in by the engine is compressed and mixed with fuel to create an explosion and produces thrust. For this reason, an engine has an air intake.

There are a variety of airplane designs in the sky. For example, some have engines integral to the fuselage, while others have separate engine pods attached to the outside.

Our midsize attack plane robot has engines on its legs, allowing it to fly while in its robot form.

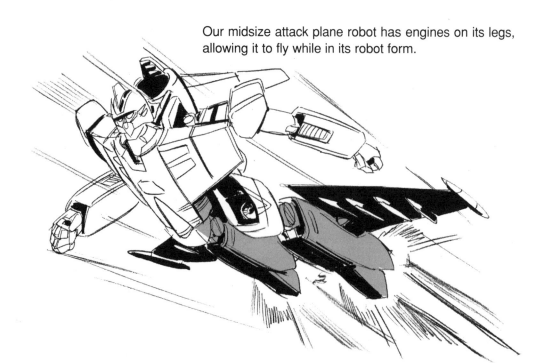

Part 3　Midsize Attack Plane

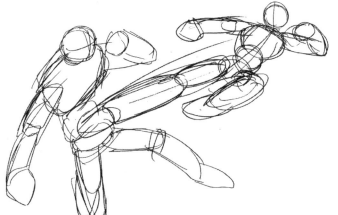

Let's draw an aerial battle scene using our midsize attack plane robot and the previous chapter's small fighter plane robot. First, draw a rough sketch of the robots in human-like poses. At this stage, draw them exactly as you would a human being. This scene shows the compact and mobile small fighter plane robot jumping up with a kick to launch a preemptive strike.

Use your sketch as a guide for drawing the robots. Arms and other parts of the human body that have a round cross section must be redrawn square.

Part 4　Bomber

The bomber is a large aircraft designed to carry out airborne assaults, and thus holds a massive quantity of ammunition. Many modern day bombers employ advanced stealth technologies. Due to its large size, many of the bomber-based transformers are conceived as robot leaders. Another reason for this is that the large bomber robot can overwhelm the enemy with its massive firepower! Let's take a look at one robot design based on the bomber.

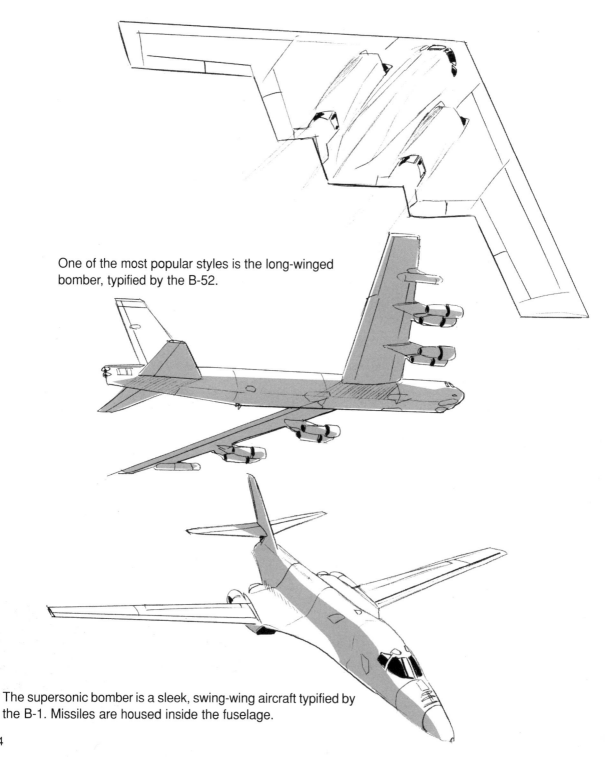

One of the most popular styles is the long-winged bomber, typified by the B-52.

The supersonic bomber is a sleek, swing-wing aircraft typified by the B-1. Missiles are housed inside the fuselage.

Part 4　Bomber

We'll examine a design based on the long-winged B-52 style bomber. It has the most "bomber-like" appearance, and has always been the more popular design.

The skillful handling of the narrow body and long wings is of primary importance when considering the robot's overall size. The main wings can become shoulder arches or cape-like structures, adding to the general sense of volume. Keep in mind the importance of a design that doesn't draw attention to the thinness of the limbs.

Part 4 Bomber

Now we'll apply the transforming mechanism developed on the previous page.

Use the vertical and horizontal tail fins to form stout legs that match the overall length of the robot. The arms are pulled out from the base of the wings.

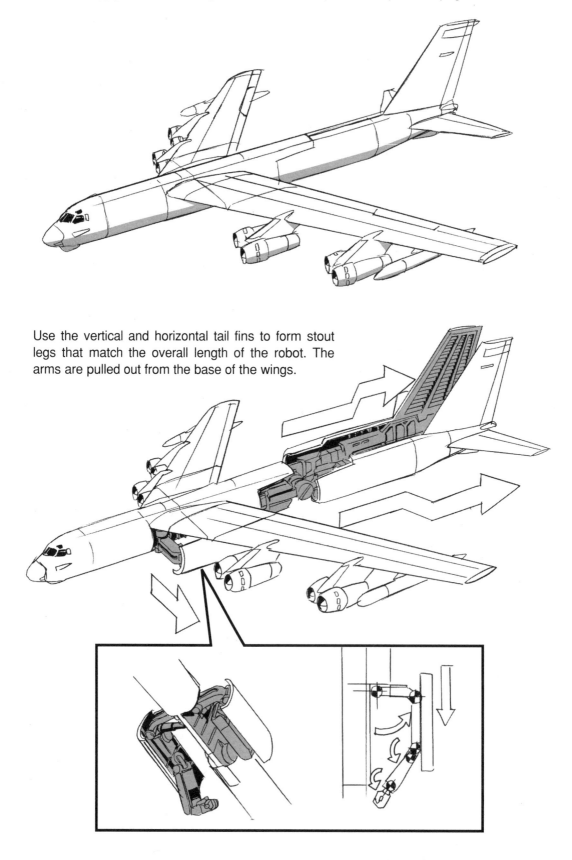

Part 4 Bomber

The nose of the plane folds forward to form the robot's chest, and the long wings hang from the shoulders to become the armor plating. The entire rear section, folded down to form the legs, rotates 180 degrees at the waist, with the vertical tail fin forming the toes.

Part 4　Bomber

This is the bomber robot completed on the previous page. It is characterized by the cape-like armor plating hanging from its shoulders, formed from the long wings. The undersides of the wings can be fitted with a wide array of weaponry.

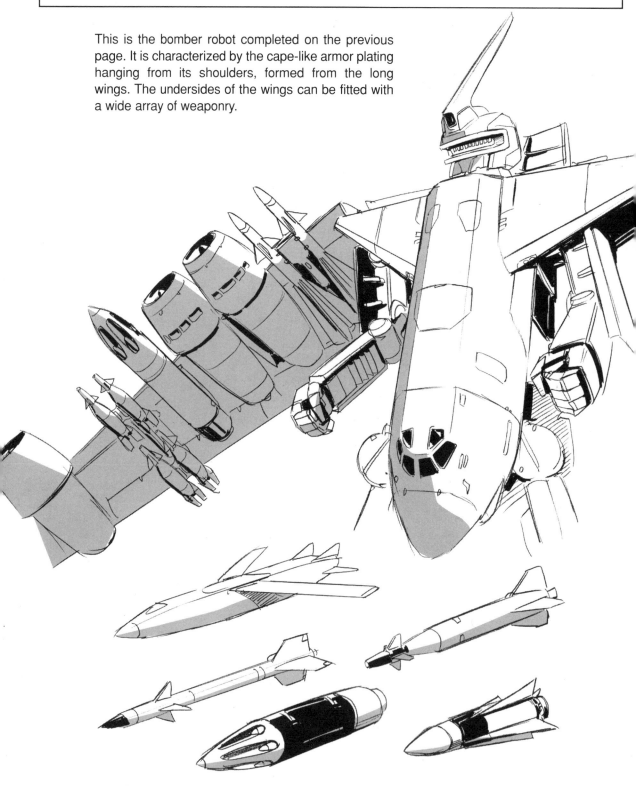

Attach cruise missiles, air-to-air missiles, napalm bombs, rocket launchers, and other weaponry to bring out the bomber-like qualities of the robot.

Part 4 Bomber

We'll now present some variations on the bomber theme. The XB-70 supersonic bomber will serve as our model. In this design, the air intakes are arranged to form the legs. Supersonic bombers often appear in this type of form.

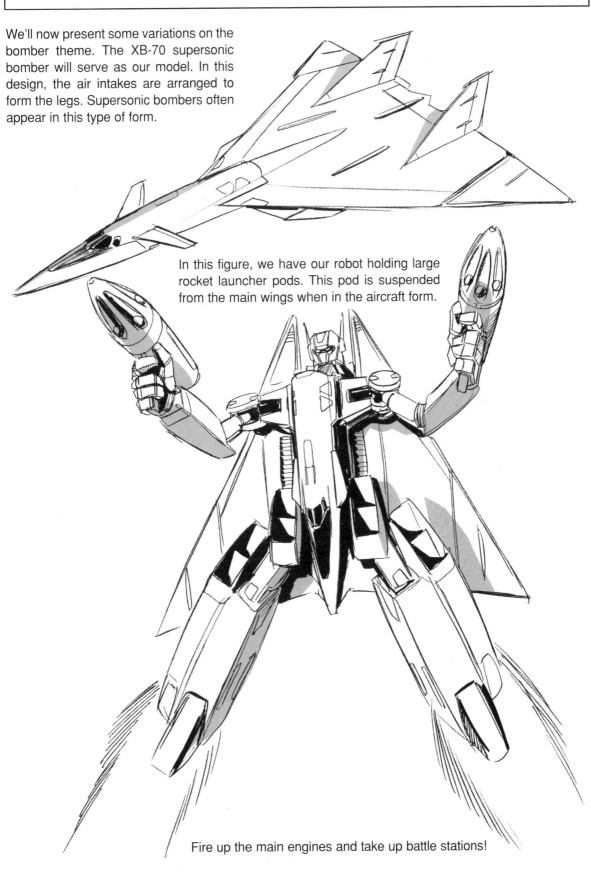

In this figure, we have our robot holding large rocket launcher pods. This pod is suspended from the main wings when in the aircraft form.

Fire up the main engines and take up battle stations!

Part 5 Helicopter

The helicopter's rotor makes it unique among the many different kinds of aircraft in the skies. The rotor is like the main wing of a regular airplane, except that it produces lift by turning at a high velocity around a fixed point. This feature allows the vehicle to take off and land vertically—no runway necessary. Furthermore, its ability to hover in midair makes it highly useful for rescue operations.

The attack helicopter is characterized by a slim fuselage and an attached, large, rotor blade driven by a high-powered engine. It can reach speeds comparable to those achieved by a small-sized propeller-driven combat airplane. Heavy-duty cargo choppers with two rotors—one in the front and in the back—which are capable of carrying large numbers of military personnel and lots of equipment.

The rotor presents a challenge when designing a transforming helicopter robot. We want to effectively incorporate this unique feature in our design.

Part 5 Helicopter

We'll use a typical attack helicopter as our example. A disproportionately large rotor and a wide canopy that ensures the pilot's excellent visibility characterize this helicopter. Other features include the wing-like weapon rack, used to mount weaponry, and the landing skids underneath, used during takeoff and landing.

Taking advantage of the attack helicopter's unique features, we'll develop a transformation mechanism that allows the robot form to use the large helicopter rotor for flight.

Part 5 Helicopter

Now let's work on transforming this attack helicopter into a robot. Our design will allow the rotor to be used for flight when in the robot form. Therefore, our transformation mechanism must keep the base of the rotor pointing upward at all times.

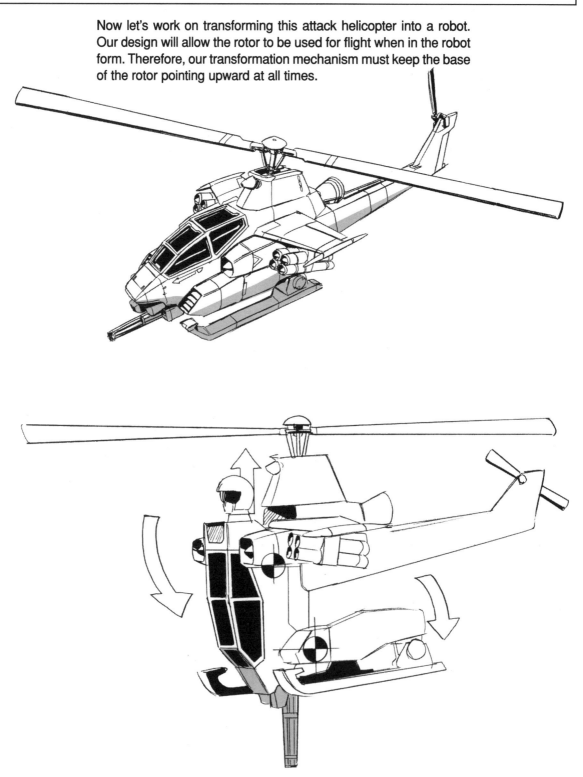

First, the entire cockpit (nose section) folds down. The robot's head emerges from the cross section of the cockpit rear, located just in front of the rotor base. The front section of the landing skid base becomes the fulcrum for folding evenly along with the rear of the fuselage.

Part 5　Helicopter

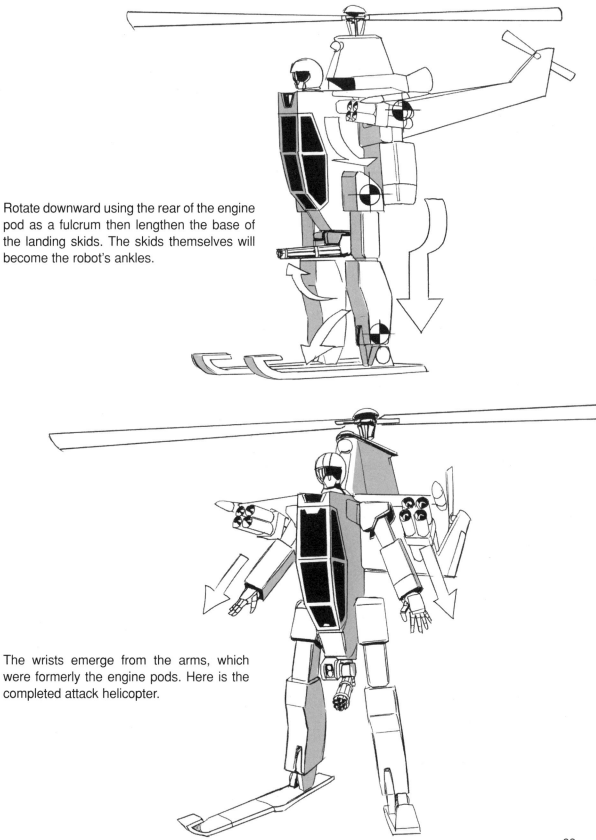

Rotate downward using the rear of the engine pod as a fulcrum then lengthen the base of the landing skids. The skids themselves will become the robot's ankles.

The wrists emerge from the arms, which were formerly the engine pods. Here is the completed attack helicopter.

Action Pose
Here, the attack helicopter robot is using its rotor blades to execute precise maneuvers.

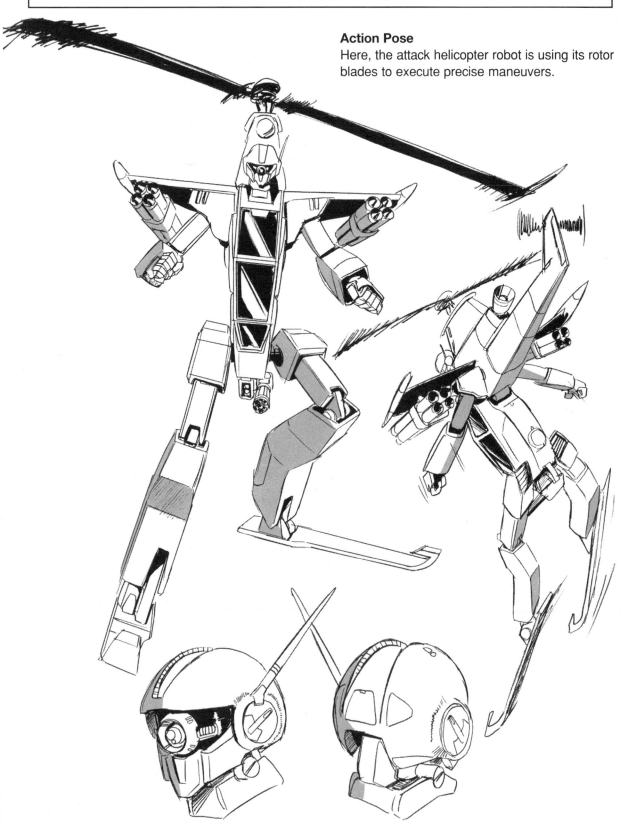

This is the robot's head, designed to resemble a helicopter pilot's helmet. Notice the sensor on one eye.

Helicopter Variations

Here, we'll examine the large double-rotor helicopter. We've come up with a transformation mechanism that allows the robot form to utilize both rotors. The nose and the rear section become the robot's legs, contributing to a striking form.

Part 6 Space Shuttle

The space shuttle is the first ever "space ferry" invented by man. Unlike the rockets that preceded it, the shuttle is equipped with a large cargo bay. It's also a reusable spacecraft, allowing for multiple trips to and from space. Such characteristics have helped the shuttle score numerous groundbreaking victories for space exploration, and it continues to operate at the vanguard of the field. Not surprisingly, this spacecraft is an extremely popular design for transforming robots.

The space shuttle can basically be divided into three sections. The shuttle's orbiter is the main spacecraft. It has a spacious cargo bay, which is equipped with a long access arm. The two solid rocket boosters generate a tremendous thrust to propel the orbiter out of the earth's gravitational sphere. The external tank, which is larger than the orbiter, is loaded with fuel that is burned off by the boosters in just a few seconds.

Part 6 Space Shuttle

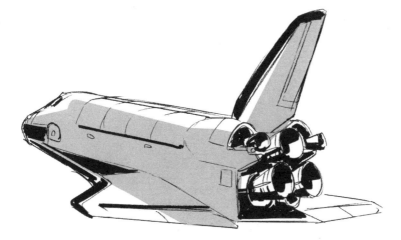

Let's examine the robot's transformation mechanism. The orbiter itself can be thought of as a slightly wide airplane, but the boosters and tank used during liftoff are unique since no other aircraft uses them.

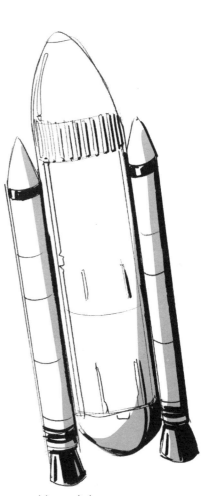

A transformer based on the orbiter alone would result in being like any other airplane-based robot. Therefore, in this chapter we'll adopt a unique transformation mechanism that incorporates both the solid rocket boosters and the external tank to create a massive transformer that packs a real punch!

Part 6 Space Shuttle

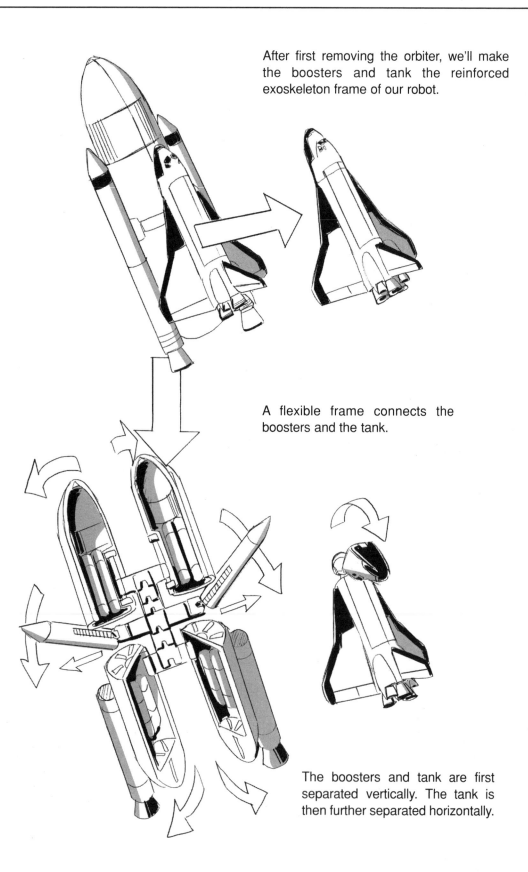

After first removing the orbiter, we'll make the boosters and tank the reinforced exoskeleton frame of our robot.

A flexible frame connects the boosters and the tank.

The boosters and tank are first separated vertically. The tank is then further separated horizontally.

Part 6　Space Shuttle

Bend in the orbiter's wings, fold the nose section and push out the robot's head

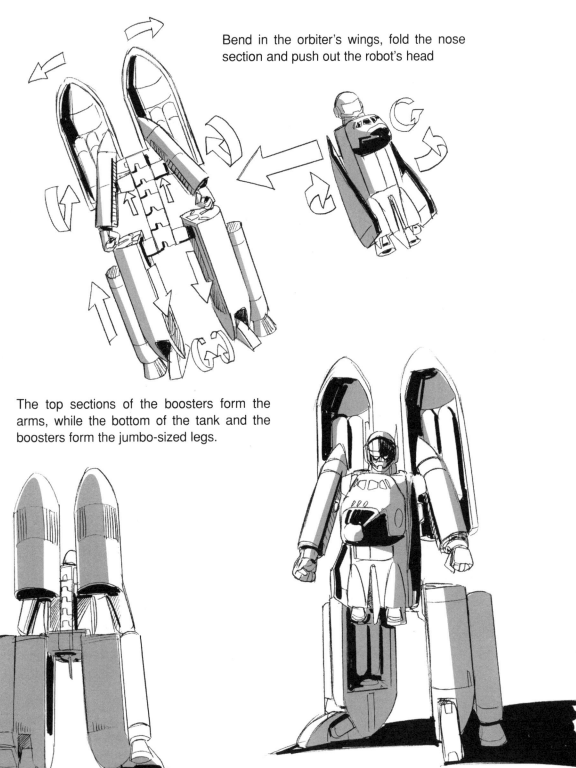

The top sections of the boosters form the arms, while the bottom of the tank and the boosters form the jumbo-sized legs.

Return the boosters to the center of the frame to complete the transformation.

Part 6　Space Shuttle

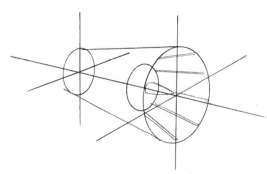

Most modern aircraft—including the space shuttle—are driven by jet or rocket engines. We'll now present directions on how to draw the nozzles on these engines. A large aircraft is equipped with many engine nozzles. You must make sure to neatly render the center of the nozzle, using that as a guide for drawing your circles. Inattention to detail at this step will result in a distorted and unsightly drawing.

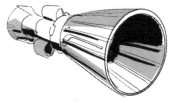

1. Decide on the base and length of the nozzle (see arrows).

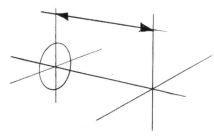

2. Next, use an ellipse ruler to draw the rear section of the nozzle.

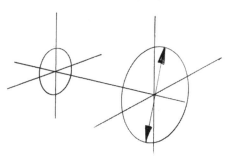

3. Connect the outlines of the nozzle's base with those of the rear section.

4. Add details to the inside and outside of the nozzle to complete the drawing.

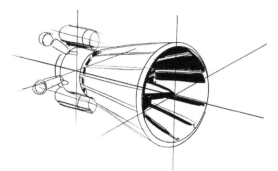

Part 6 Space Shuttle

Here is the space shuttle robot firing its boosters and soaring through the air. The robot's head was designed to resemble an astronaut's helmet.

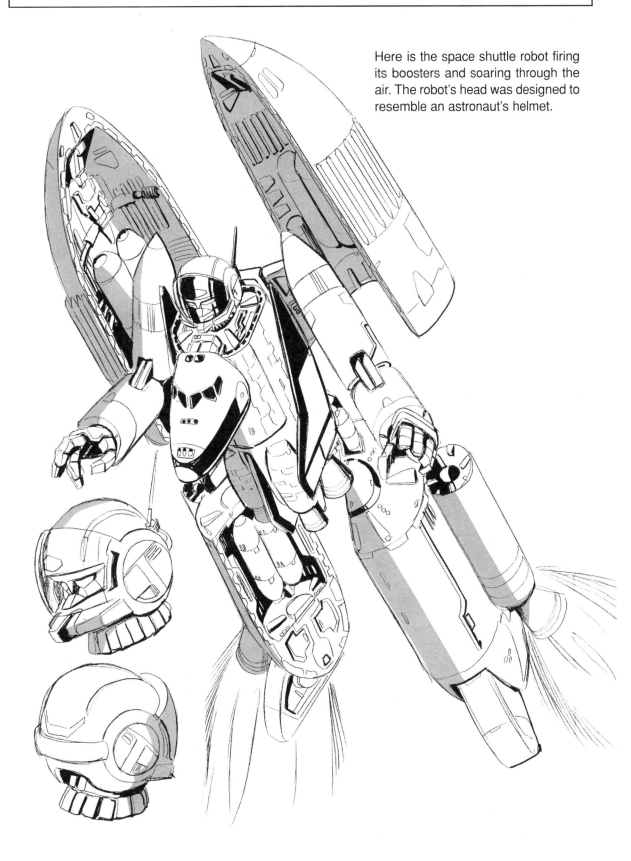

Examples of Transforming Robots

On this page, we'll introduce an aircraft-based transformer by PLEX as one example of a commercially available design.

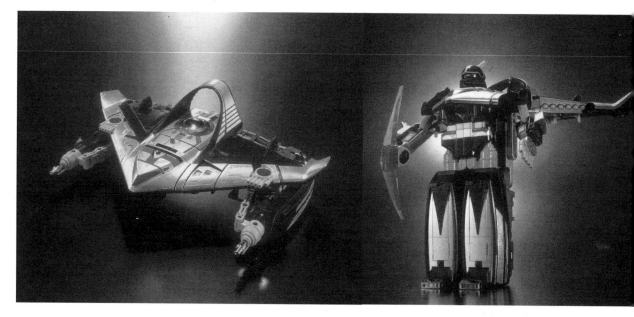

Our example is the *Deluxe Time Shadow Megazord*, a stealth bomber transforming robot from the future featured in *Power Rangers Time Force*. Its transformation mechanism was carefully thought out; its large wings are unaffected by the transformation process, allowing the robot to use them for flight. Furthermore, the arm housing in the anterior edge of the wings reveals missile launchers when in the robot form. Thanks to many years of experience in designing transformers, this kind of attention to detail has become the hallmark of PLEX.

In the next chapter, we'll cover animal-based robots. Creating animal transforming robots requires a design philosophy different from mechanical cars and aircraft we have seen so far.

Chapter 5

From Animal to Humanoid Robot

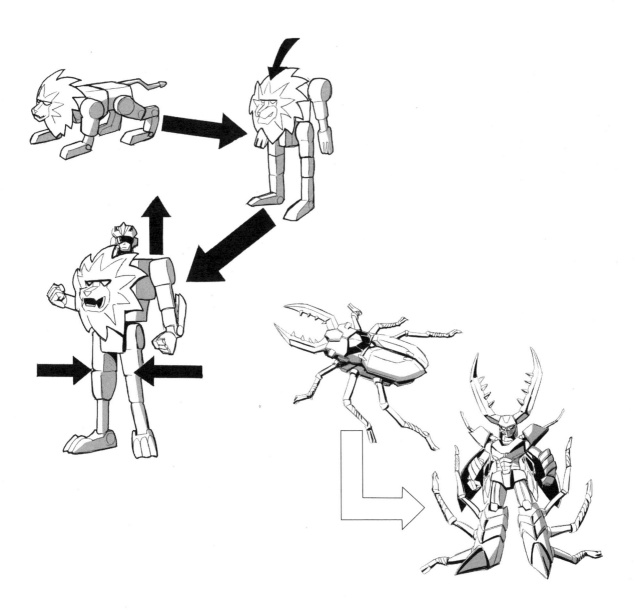

Part 1　From Animal to Humanoid Robot

In this chapter, we'll take a look at transformers that change from animal shapes to humanoid robots. The "animal" category consists of a wide variety of creatures. As you are surely aware, there is substantial variation even in the number of legs that an animal possesses (see below). In contrast to the mechanical vehicles in the previous two chapters, humans and animals have many body parts in common. Not everything corresponds, of course, but animals often have the same basic body parts, such as a head, legs, and body. It would seem logical enough to make an animal's head, legs, and other parts directly correspond to the same body parts of a robot, but rarely does the transformation mechanism allow the application of this design method.

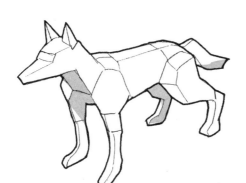

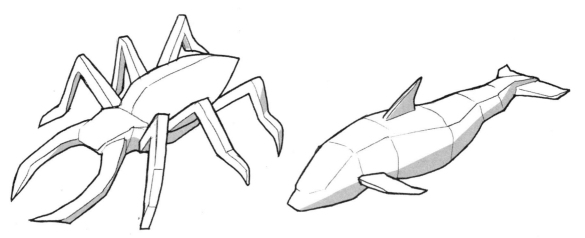

Rather than simply making the body parts correspond to each other, we must base our transformation mechanism on the idea that the animal is actually comprised of several blocks (hexahedrons).

Part 1 From Animal to Humanoid Robot

We'll now work to design a transformer based on a dog. The dog is a good example of a four-legged animal—a popular theme for transformer designs. First, we'll create a mechanical dog robot, reducing its various parts to blocks and simplifying the lines.

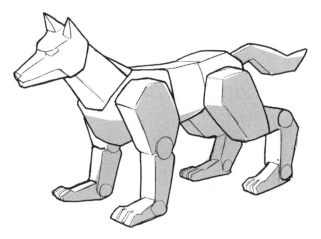

Let's examine the dog in profile. Can you see which parts could potentially become the humanoid robot's body parts? Next, we'll try standing the dog upright. The limb lengths remain unaltered in this position. In addition, the dog's head still functions as the head, giving the figure an unbalanced look.

In this figure, we've taken the dog's head—as seen in the side view on the previous page—and shifted it to the humanoid robot's chest. We've also lengthened the dog's hind shanks, bringing the robot closer to a humanoid form.

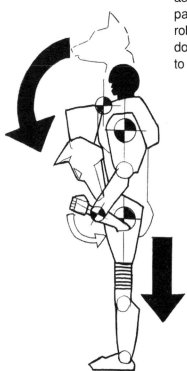

We could even shift the dog's head toward the back of the humanoid robot.

After transformation, the dog's head ends up as a symbol on the humanoid robot's chest, drawing attention to the kind of animal from which it transformed.

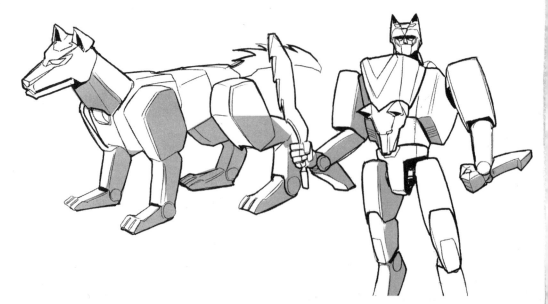

Part 1　From Animal to Humanoid Robot

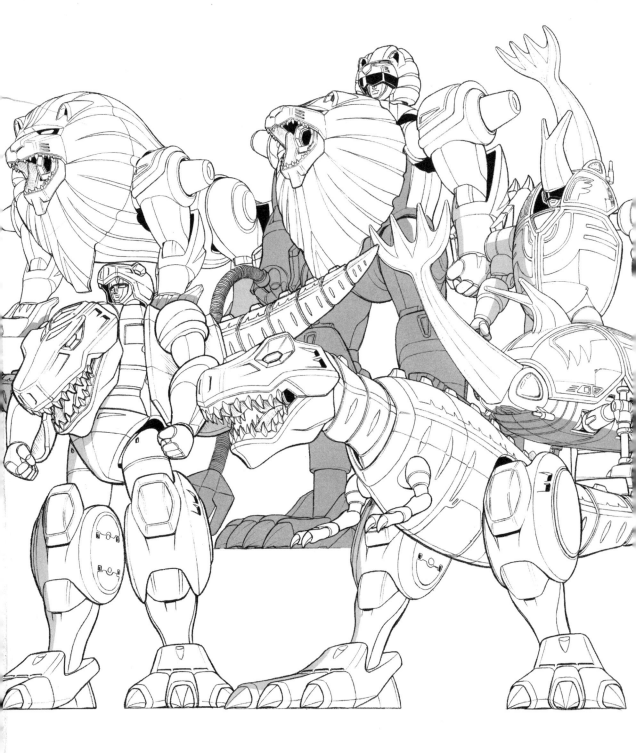

This chapter covers the three most popular living things on which transformers are based: animals, insects and dinosaurs. If you master these basic transformation patterns, you'll be able to transform almost any creature into a robot.

Part 2 Lion

Perhaps the most popular animal used for transformers is the lion, the fundamental form for all four-legged beasts. Japanese manga often feature a lion transformer in the leading role, a testament to its popularity.

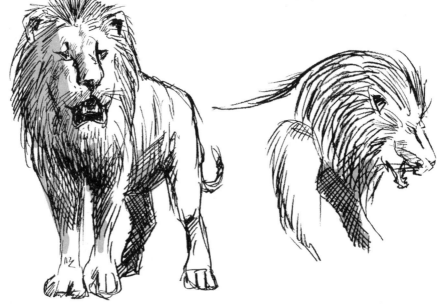

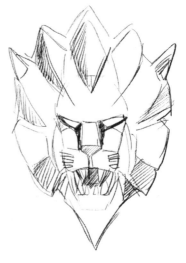

The lion's most distinctive feature is, of course, its mane, something no other four-legged animal possesses. Many robot designs accentuate the volume of the mane and treat it as the lion's trademark characteristic.

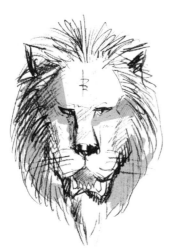

Part 2　Lion

Together with its mane, the lion's head is the most unique external feature. Therefore, we should probably try to leave the head visible on some part of the humanoid robot as the lion's special symbol. In fact, deciding on where to shift the head is one of the key points of our design.

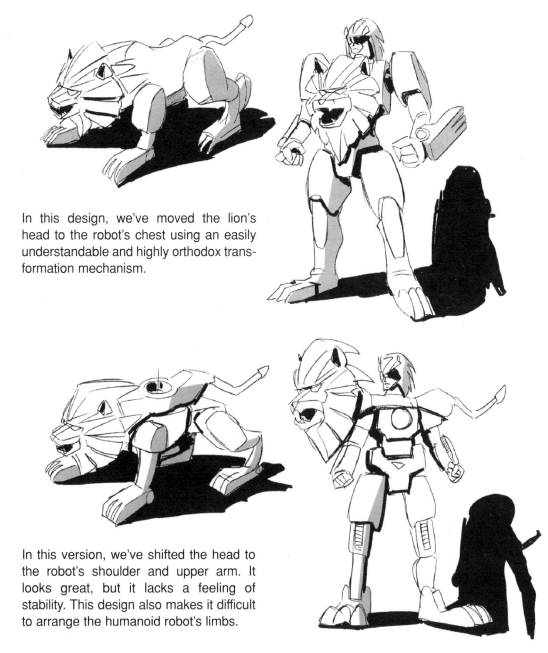

In this design, we've moved the lion's head to the robot's chest using an easily understandable and highly orthodox transformation mechanism.

In this version, we've shifted the head to the robot's shoulder and upper arm. It looks great, but it lacks a feeling of stability. This design also makes it difficult to arrange the humanoid robot's limbs.

Part 2　Lion

Now we'll develop for our lion transformation, a mechanism based on the orthodox head-on-chest design shown earlier.

First, stand the lion's body on its hind legs. Next, move the head down to the abdomen and lengthen the hind legs. To complete the transformation, pull out the humanoid robot's head from the cross section that resulted from shifting the lion's head.

Part 2 Lion

We'll now work to flesh out the transformation plan on the previous page.

Lion form: While emphasizing the mane, we'll add "mecha-lion" design details that have no effect on the transformation.

Robot form: The big claws on the hind legs become the legs of the humanoid robot. Notice how the lion's face on the chest adds an intense energy to the design. The tail can be removed and used as a whip.

The final design

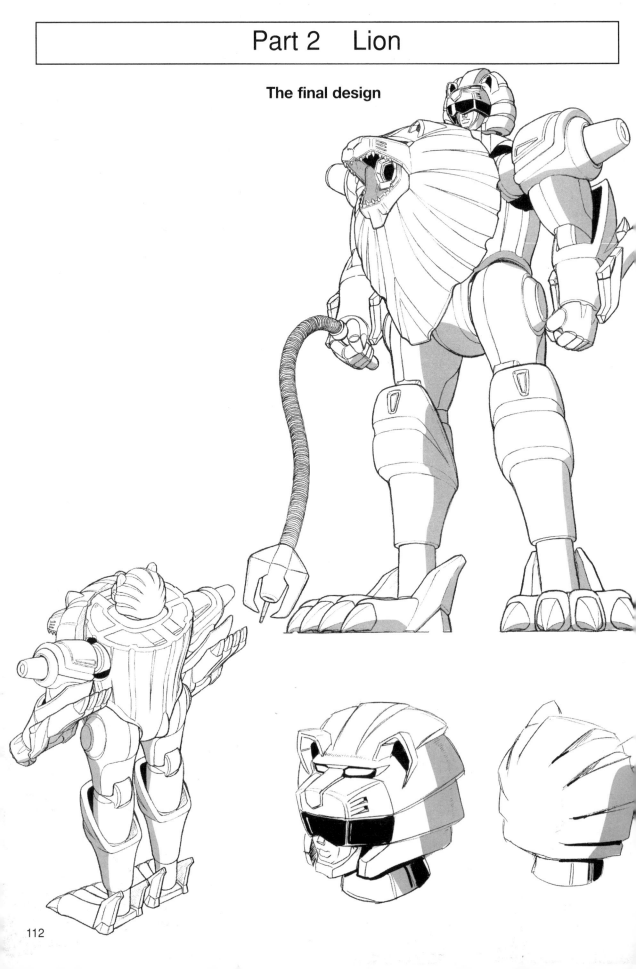

Part 2　Lion

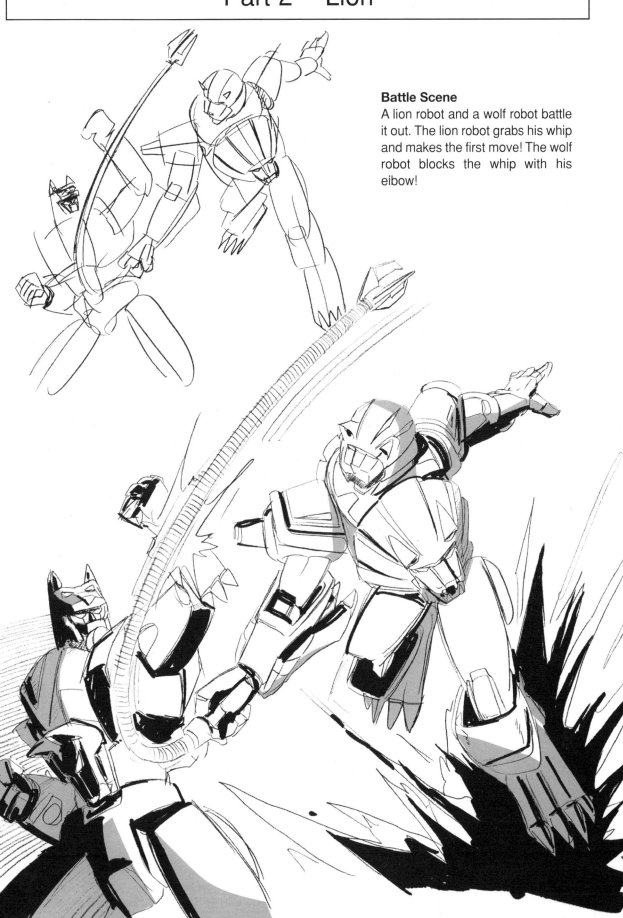

Battle Scene
A lion robot and a wolf robot battle it out. The lion robot grabs his whip and makes the first move! The wolf robot blocks the whip with his eibow!

Part 3　Insect

Insects are also popular themes for transforming robot designs. A rhinoceros beetle is a type of insect with a hard external shell. This shell is almost mechanical in its form. In this chapter, we'll present a rhinoceros beetle robot as an example of a transforming insect.

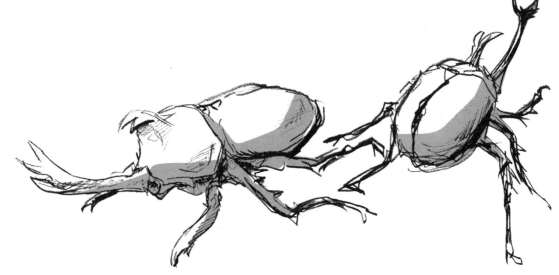

The rhinoceros beetle is characterized by its long horn. Depending on how you deal with this horn, the resulting humanoid can take on drastically different forms.

Another characteristic of this insect is its sheathed wings.

Part 3　Insect

The rhinoceros beetle has a comparatively large body that boasts substantial volume. Therefore, you don't need to worry too much about finding spaces to fit the humanoid robot's arms and legs.

Rhinoceros Beetle　　　　　　Grasshopper

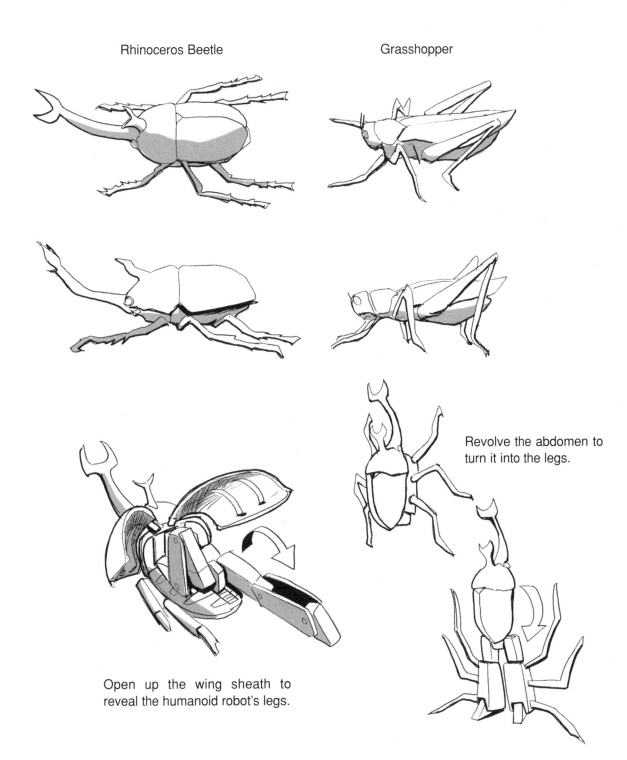

Revolve the abdomen to turn it into the legs.

Open up the wing sheath to reveal the humanoid robot's legs.

Part 3 Insect

Now we'll develop a suitable transformation mechanism.

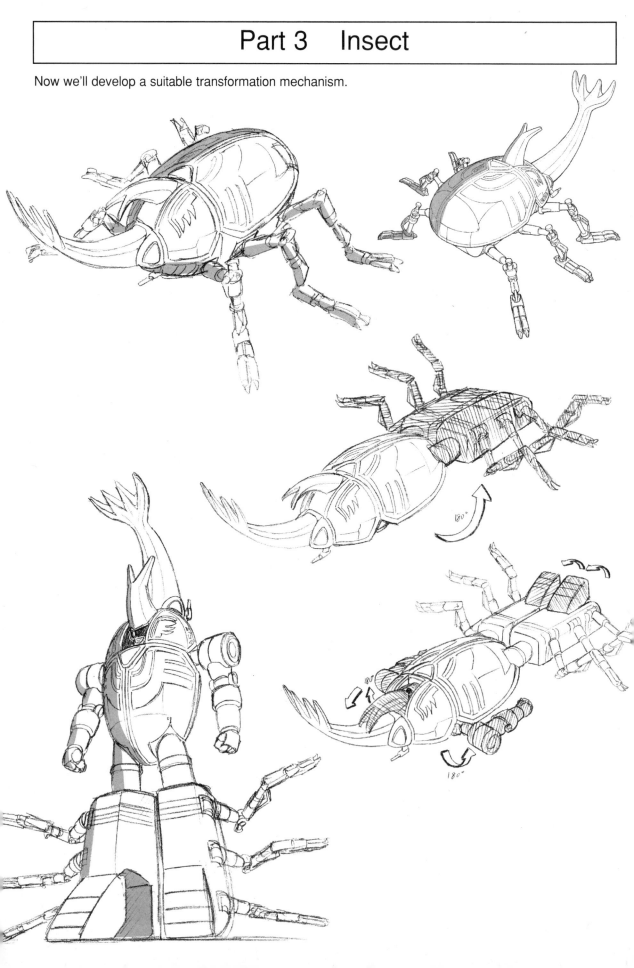

Part 3　Insect

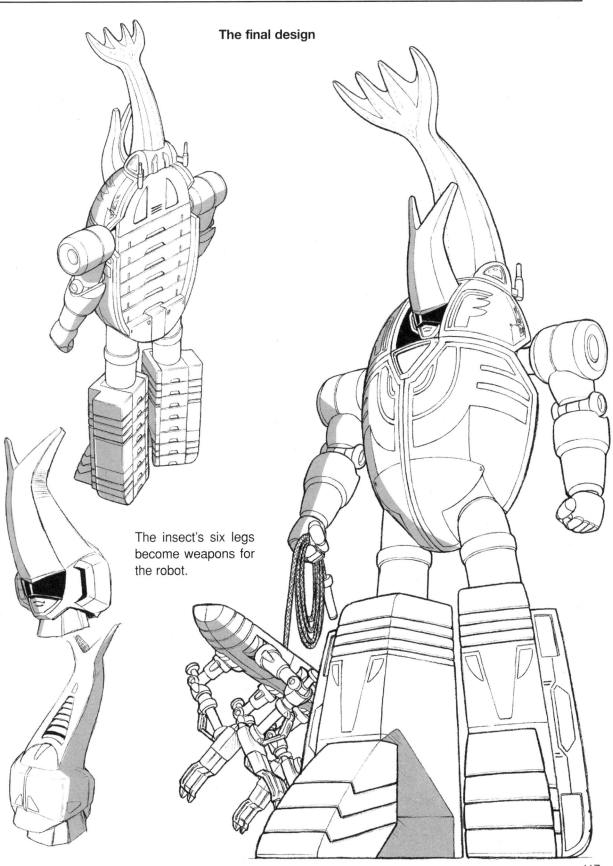

The final design

The insect's six legs
become weapons for
the robot.

Part 3　Insect

Variations on the insect transformer theme: The following are several insect transformers that use the rhinoceros beetle's transformation mechanism.

Stag Beetle
This insect is also characterized by its large horn (it's actually the jaw).

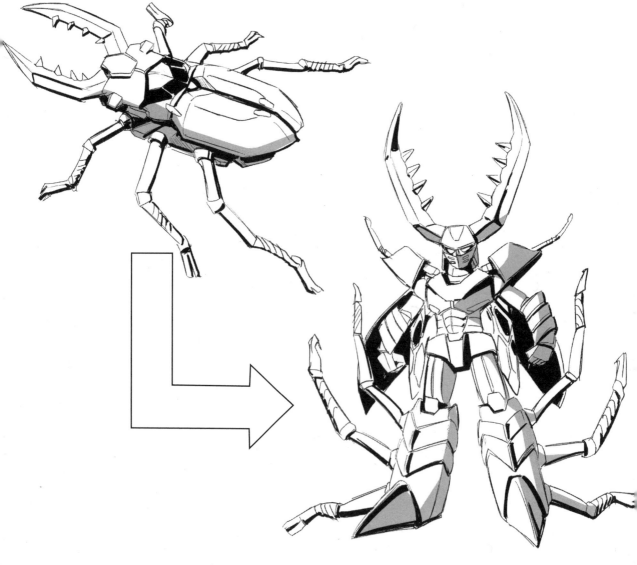

Part 3 Insect

Spider

Strictly speaking, spiders are not insects, but nevertheless another popular design. Its distinguishing feature is its eight legs.

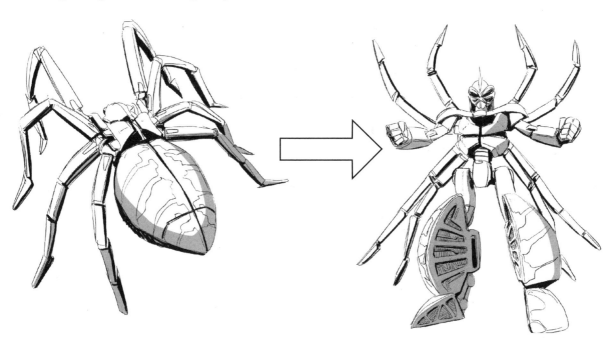

Ladybug

This insect is notable for its round body. Its adorable appearance completely changes when it transforms into a brave warrior robot.

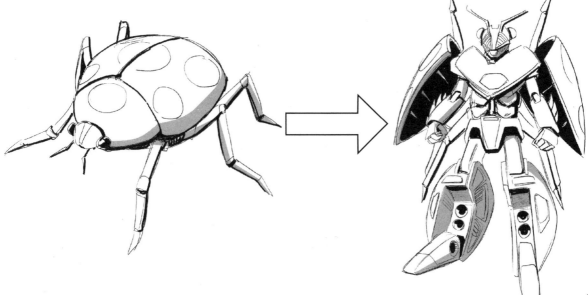

Part 3 Dinosaur

Although dinosaurs no longer inhabit the earth, they continue to stimulate our imagination. That's the reason why there are so many dinosaur transformers around. So, for the last part of the animals' section, we'll focus on the ever-popular dinosaur. Bigger and stronger than modern-day animals, dinosaurs are loved by children and adults alike. Let's get to work in creating a dinosaur that transforms into a powerful humanoid robot!

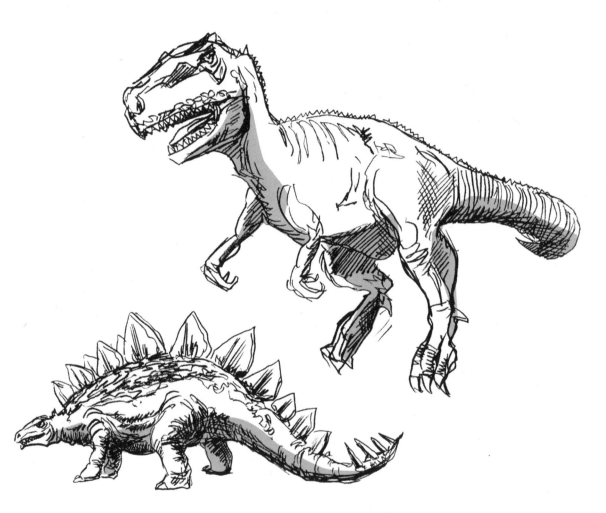

The illustrations above show that dinosaurs can generally be classified into two categories: two-legged species (e.g. Tyrannosaurus Rex) and four-legged species (e.g. Stegosaurus). Since four-legged types can utilize a transforming mechanism identical to the one previously used for the lion, we'll turn our attention here to the two-legged types, using as our example the most powerful and famous one of them all: Tyrannosaurus Rex.

Part 3 Dinosaur

The two-legged Tyrannosaurus is distinguished by its large head, massive legs and thick tail. In our design, we must determine where to reassign these three parts in the humanoid robot form.

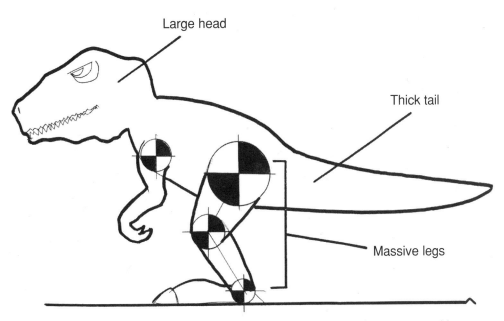

Large head

Thick tail

Massive legs

As you can see, the balance in the body parts sharply contrasts with what we have seen in the previous animals. Thus, adopting the same transformation mechanism used for the lion (front legs become the arms, hind legs become the legs) results in:

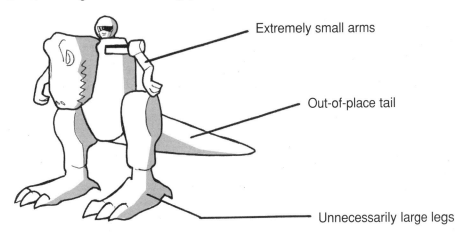

Extremely small arms

Out-of-place tail

Unnecessarily large legs

Adopting this method results in an unnatural form that is, simply put, a poor design.

Part 4 Dinosaur

Now we'll develop a new transformation mechanism for our dinosaur. We'll also decide on design details that will give it a "mecha-dinosaur" look and form.

First, fold the entire neck of the T-Rex downward. Open the chest up wide and invert it to bring out the humanoid robot's arms. Our dinosaur's head will then fold into the space formerly occupied by the arms we just took out.

Part 4　Dinosaur

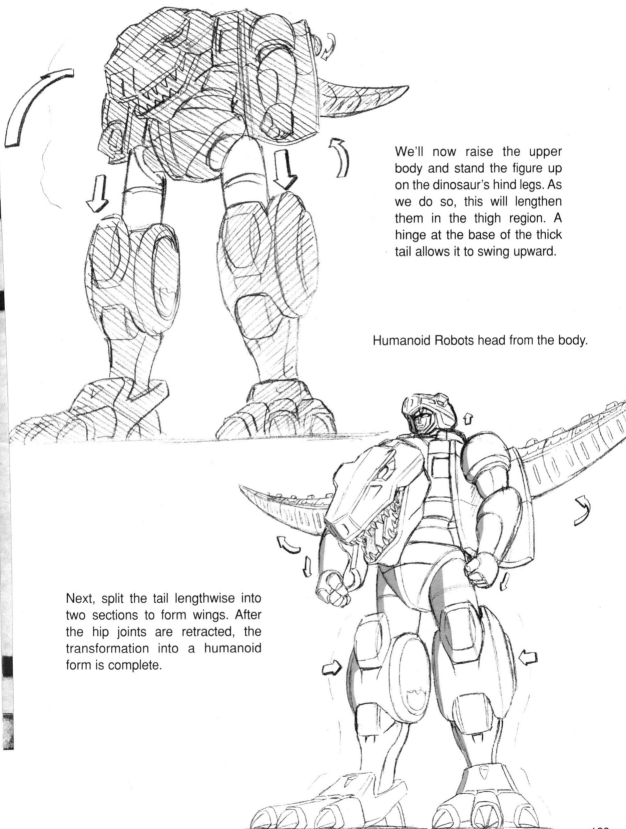

We'll now raise the upper body and stand the figure up on the dinosaur's hind legs. As we do so, this will lengthen them in the thigh region. A hinge at the base of the thick tail allows it to swing upward.

Humanoid Robots head from the body.

Next, split the tail lengthwise into two sections to form wings. After the hip joints are retracted, the transformation into a humanoid form is complete.

Part 4　Dinosaur

The final design

Affixing the T-Rex's head to the robot's chest demonstrates an excellent use of the animal's unique characteristics. Also, the surprising use of the tail to form wings results in a dynamic look for this transformer.

Part 4 Dinosaur

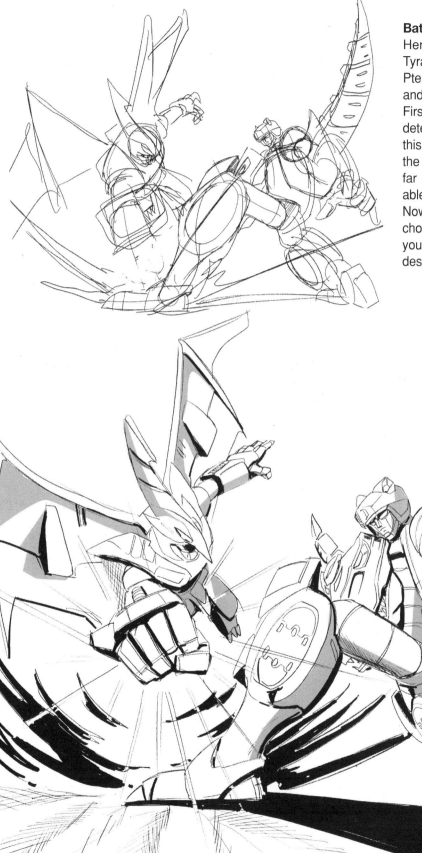

Battle scene

Here's a battle between a Tyrannosaurus Rex robot and a Pteranodon—dinosaurs of the land and air engaging in heated combat. First a rough sketch is made to determine the composition. Then this sketch is used as a guide for the final copy. If you've made it this far in the book, you're sure to be able to produce a fine drawing! Now, why not try your hand at choosing new themes and creating your own original transforming robot designs!

Examples of Transforming Robots

The first animal-based transformer design we'll introduce is the *Defender Torozord*, featured in *Power Rangers Lost Galaxy.* It transforms from a wild bull into a humanoid robot.

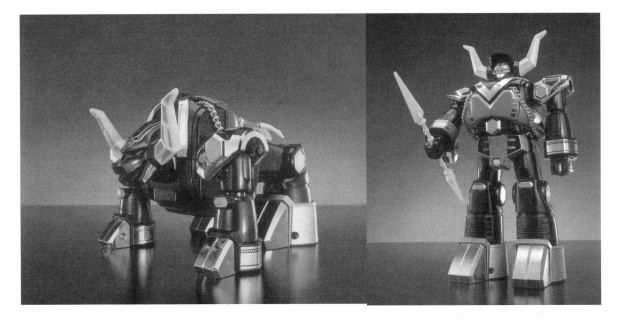

Our other example is the *Deluxe Quantasaurus Rex Megazord*, which appears in *Power Rangers Time Force*. It transforms from a futuristic mecha-dino into a humanoid battle robot. One feature of this product deserves a special mention: It transforms automatically via remote control, without any assistance from human hands. It is truly a masterpiece of design. Creating conceptual drafts leading to this type of product is just one aspect of the work undertaken by PLEX. Not only does PLEX design robot characters, it is a planning and design group that actively markets them and works to maximize their commercial potential.

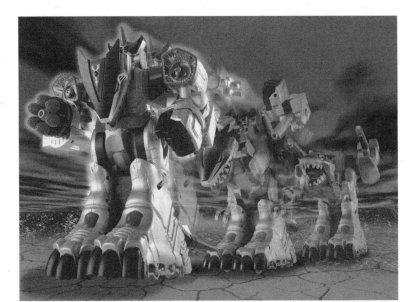

PLEX Information

Let's Draw MANGA TRANSFORMING ROBOTS

Drawing and production : Yasuhiro Nitta (PLEX Co., Ltd.)
Cover drawing and coloring : Yasuhiro Nitta (PLEX Co., Ltd.)

Special Thanks to : Yoshiyuki Teshima (HALBERT)
:Taishi Kato (Robo Taicyou)

Superviser : Masayuki Kondo (PLEX Co., Ltd.)

COMING SOON!!!

More!!!

Let's Draw MANGA 漫画

Let's Draw Manga - Astro Boy
By: Tezuka Productions
ISBN :1-56970-992-0
SRP: $19.95
Softcover w/ Dustjacket, 7 1/8"
Approx: 128 pages in B&W
English text, Digital Manga Pub
NORTH AMERICAN TERRITOR

Astro Boy, the most recogni____ classi_ Japanese ____ d character, is making a large comeback in Japan and acro__ America. WB K___ is ___ing ___ air the new *Astro Boy* series later this fall and Columbia pictures is releasing a CG animated movie of Astro Boy shortly after. Now is a great time to stock up on Japan's most lovable robot.

This volume of the *Let's Draw Manga* series will provide the readers with all the wonderful characteristics that makes Osamu Tezuka's Astro Boy one of the greatest animated characters ever. Astro Boy's popularity and global appeal in the animation world are rivaled only by Walt Disney's Micky Mouse, both of whom are major power houses in the cartoon business! Inside, you will find pages fully explaining and illustrating all the different views, proportions and attributes of Astro Boy, never reavealed in such fine detail in the past, thereby making this book a must-have for kids and teens alike.

Let's Draw Manga - Ninja & Samurai
By: Hidefumi Okuma
ISBN : 1-56970-990-4
SRP: $19.95
Softcover w/ Dustjacket, 7 1/8" x 10 1/8"
Approx: 118 pages in B&W
English text, Digital Manga Publishing (DMP)
NORTH AMERICAN TERRITORY

Fueled by classic hits such as the animated film, *Ninja Scroll* and the best-selling manga, *Lone Wolf and Cub*, the Western audience's fascination with ninjas & samurai has reached peak levels over the last few years. In this book, the artist will learn to draw about the daily life and tools of the legendary samurai and their most menacing foes, the ninja along with a wide variety of characters including feudal lords, the Kunoichi "female ninja", the mendicant zen priests, merchants, and much, much more. By providing the readers with a close and detailed look at their appearances, facial expressions, clothing and weaponry, artists will gain the knowledge and ability to create great looking comics of this genre. This book will serve as a one-of-a-kind reference for any manga artist aspiring to create his or her samurai and ninja action series.

Let's Draw Manga - Sexy Gals
By: Heisuke Shimohara
ISBN : 1-56970-989-0
SRP: $19.95
Softcover w/ Dustjacket, 7 1/8" x 10 1/8"
Approx: 118 pages in B&W
English text, Digital Manga Publishing (DMP)
NORTH AMERICAN TERRITORY

Sexy and appealing *Let's Draw Manga- Sexy Gals*, helps to deliver that romantic element to a person's work that may be missing. Drawing beautiful women and men in seductive poses can be one of the trickiest and most problematic for an artist to depict sincerely. Long flowing hair, body proportions, poses and clothing that hang by a thread are just some of the attributes that will help to lend to the physical attractiveness and prowl-ness of your drawings. Miniskirts and open shirts with a touch of soft and heavy petting. *Let's draw Manga- Sexy Gals* is a fun and flirtatious book with a provocative look at suggestive comics.